DATE DUE

APR 15 1993	
APR 12 1994	
MAY 20 1994	
NOV 1 1994	
FEB 20 1996	
MAR 12 1996	
MAR 27 1996	
APR 15 1996	
APR 24 1997	

Vision and Revision

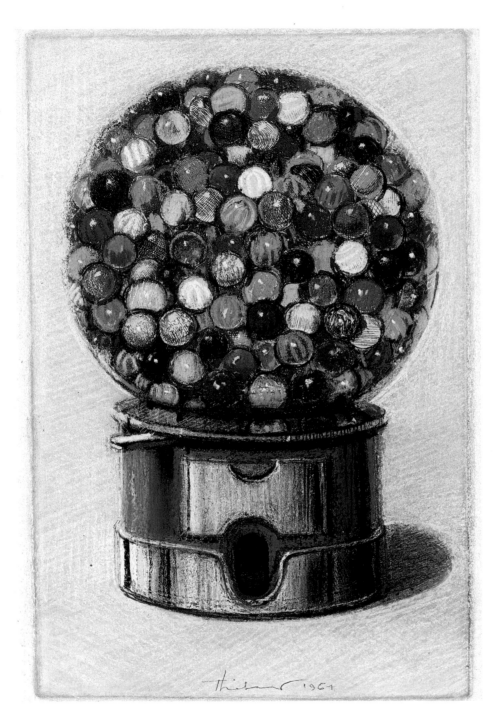

Gum Machine 1964
pastel over hard-ground etching
12″ x 8″

Vision and Revision

Hand Colored Prints
by Wayne Thiebaud

Introduction by
Wayne Thiebaud

Essays by
Bill Berkson and
Robert Flynn Johnson

Chronicle Books
San Francisco

©1991 by Wayne Thiebaud

Essay ©1991 by Bill Berkson

Essay ©1991 by Robert Flynn Johnson

First Edition

ISBN 0-8118-0225-6 (paper)
ISBN 0-8118-0200-0 (cloth)
ISBN 0-8118-0217-5 (limited)

Library of Congress Catalog Card Number
91-17207

Library of Congress Cataloging-in-Publication
Data is available

In December 1991, an exhibition entitled *Vision and Revision: Hand-Colored Prints by Wayne Thiebaud* will open at the California Palace of the Legion of Honor, The Fine Arts Museums of San Francisco. This volume serves as the catalogue for the exhibition.

Distributed in Canada by
Raincoast Books
112 East Third Avenue
Vancouver, B.C. V5T 1C8

10 9 8 7 6 5 4 3 2 1

Chronicle Books
275 Fifth Street
San Francisco, California 94103

PRINTED IN JAPAN

Note:
The date given for each color plate reflects the date the print was hand colored by the artist rather than the date the print was originally created.

For my son Paul

Contents

Acknowledgments

I would like to acknowledge the following print houses and printers: Kathan Brown, Lawrence Hamlin, Peter Pettengill, and Stephen Thomas of Crown Point Press, San Francisco; Jaime Arnera Printing Co., Vallauris, France; Fleming Silkscreen, Sacramento; David Salgado and Mark Field of Trillium Graphics, Brisbane; Robert Feldman and Parasol Press, New York; Patrick Dullanty; Wolf Kahn; Michael Knigin; Nathan Oliveira; Bill Scholer; California State University at Sacramento; and the University of California at Davis. Hackercolor and Ferrari PhotoLab, both of Sacramento, and Sixth Street Studios, San Francisco, photographed the transparencies of the artwork.

I am especially grateful for the generosity and support of Matthew Bult and Betty Jean Thiebaud.

Lenders to the Exhibition

The Fine Arts Museums of San Francisco,
Achenbach Foundation for Graphic Arts,
Hamilton-Wells Fund

Gretchen and John Berggruen

Matthew L. Bult

Glenna and Charles Campbell

Morgan Flagg

Nan Tucker McEvoy

Deedee and Burton McMurty

E. J. Russell

Mr. and Mrs. Allan Stone

Mr. and Mrs. Gary M. Sumers

Betty Jean Thiebaud

Paul LeBaron Thiebaud

Collection of the Artist

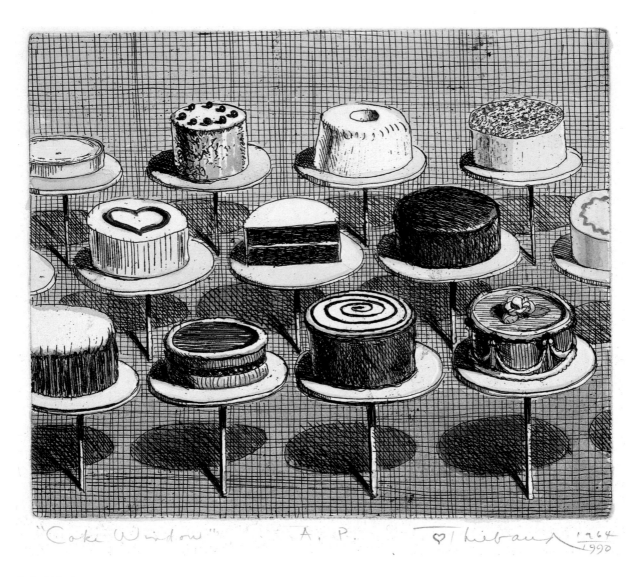

"Cake Window" A. P. ♡Thiebaud 1964/1990

Cake Window 1990
watercolor over hard-ground etching
5" x 6"

Changing Prints
Wayne Thiebaud

Do the same drawing over and over again and again . . . ten times . . .
a hundred times.
 —Edgar Degas

For an artist . . . a pencil eraser is just as useful as its point.
 —Willem de Kooning

I think the most compelling part of drawing and painting is the continuing thrill
of learning about how they can be made. Working on prints is an extension of this
constant search. For over forty years I have been making lithographs, silkscreens,
woodcuts, linocuts, monotypes, and etchings. I printed some of these, but most were
printed by highly accomplished printers in various studios. I would like to thank all
of them for being so helpful to me.

On a few lucky occasions a first proof pulled from the press appears to be complete.
But this is a rare occurrence because most often the print needs adjustments, further
work, and several additional stages. Actually it is this potential for change that cap-
tivates me. Trial proofs offer a chance to experiment with variations and permutations
that can be transmitted to the next stage. And while such a procedure is going on
it is possible to see alternatives that suggest fresh directions and result in new prints.
At other times the process of creating prints may make the artist feel utter hopeless-
ness—his proof being nothing more than a well-printed failure. But a painter lives on
hope and must learn to use the nerve of failure as a positive tool.

The mysterious process of painting and drawing has always used both construction and destruction with positive results. "My pictures are often made by a sum of destructions," Picasso declared. Putting in, taking out, adding and subtracting, stumbling around, glazing across, erasing, collaging upon, patching over, breaking and fixing can all be put to use as a work is being pursued.

This curious contradictory activity poses some interesting questions. When is a work finished? And how does that differ from work that feels complete? Cézanne wished to avoid the finished, but worked obsessively towards his special human notion of the complete. This ability to understand and determine completeness is part of the human capacity for empathy: by that I mean our ability to transfer ourselves into things — such as paintings and prints — and to actually feel their physical properties. This is a particularly important kind of empathic vitality requiring an openness to experience. When an artist or viewer feels involved in a work, they relate to that work as a living thing, with a sense of exhilaration and freshness of spirit. It is primarily an intuitive process that can give the work a life force. In contrast, finishing off demands an intellectual process, a neat tying together of things in a way we "think" is correct. This tends to deaden a work because it's difficult to enter into a form that is totally stabilized and finished off. Absolute resolution can be dangerously close to the art of taxidermy.

The editioning of prints over the years has produced all kinds of print proofs: proofs that were never made into editions, proofs of unfinished works, proofs printed on different kinds of paper, progressive color trial proofs, and so on. This resulted in a group of pre-established images printed on fine papers — elegant surfaces I could not bear to throw away. So I kept them around the studio and on occasion would glance at them. From time to time they seemed to flirt an invitation my way, suggesting possibilities for revitalization. Change me, rework me, overhaul my parts, give me a face-lift, they beckoned — either finish me off or complete me. (Can anyone raise the dead, really?)

In the reworking of these prints I have used assorted media including pen and ink, graphite, crayons, pastels, watercolor, charcoal, tempera, oils, and acrylics in order to change them in as many ways as I could. Surprising results occurred while this

strange practice was going on, and these stimulated speculation about a number of issues. For instance: what happens to a pre-established matrix, structure, or pattern configuration when it is acted upon with changes of hue, value, or intensity? Would this significantly change the space or light or hierarchy of things? Can a bright daylight scene be transformed into a dark night scene or a foggy atmospheric landscape? Can new interest be added with the introduction of new units, a man placed in an empty window, for instance? What happens when an entire section is eliminated or the picture is cropped to a smaller size? Does this augment the size or scale of the composition? If outlines are softened or painted out would the work be improved? And, as in music, can transposition be used to change effectively the visual register, taking a medium range value composition to an all high value level or to a very dark low value tonality? These kinds of problems and many others are what prompted most of these works. It was fascinating to discover how unlimited the possibilities appear to be.

Along with all of these options are the difficulties inherent in attempting to judge a work. A painter must constantly try to interrogate his production critically and work to correct problems that interfere with the completeness of a composition. An artist must be on guard against the danger of producing something simpleminded rather than simple or making something complicated instead of developing something truly complex, and be able to acknowledge when the original print is better than the "gilded lily" unwittingly produced. I hope we have eliminated most of these kinds of productions, because the final aim was to select works that distinguish themselves as separate and unique entities. Certainly there are familial resemblances to the parent print—brothers, sisters, and shirttail cousins—hopefully there are no twins.

Finally, I believe being a painter is a very special privilege; it is a joy to try to be a part of the long and enduring tradition of the language of vision. My efforts are a result of having seen so many examples of rare achievements from which I could draw both inspiration and information. Another essay is necessary to disclose all of the many influential artists who helped me in my pursuits. Beautiful handworked prints by people such as Castiglione, Rembrandt, Goya, Blake, Degas, Gauguin, Lepic, and others from centuries before were thrilling examples. And the enlivened and stunning works by contemporaries like Picasso, Matisse, Morandi, Johns, Hodgkin, Dine,

Diebenkorn, Oliveira, as well as many others exist as rare examples of the print-making arts, and give me rich and lasting pleasure.

As I began work on the prints assembled here I considered each as an individual autonomous piece. The idea for an exhibit of the works as a group only developed after they were brought together to be photographed and documented. I hope they will be as interesting for others to see as they have been for me to work upon. I thank my family and all of those who have helped make this project possible.

Vision and Revision

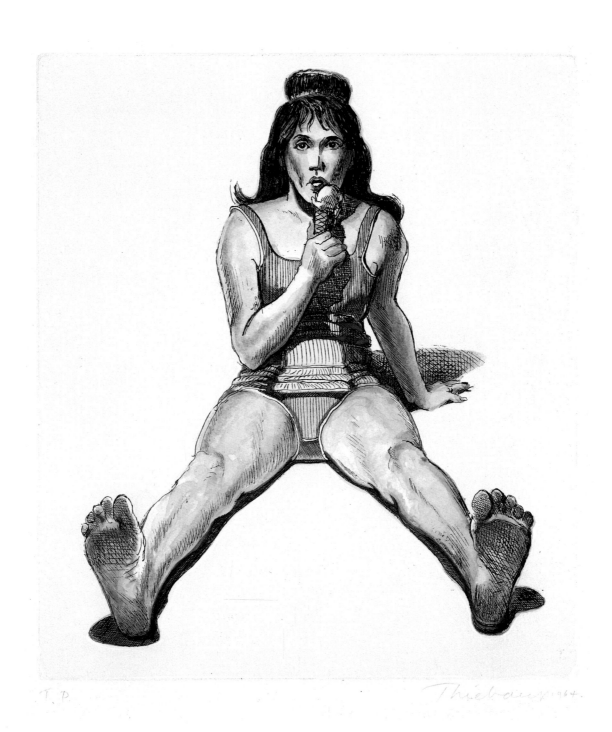

Girl with Ice Cream Cone 1964
watercolor over hard-ground etching
7" x 6"

17

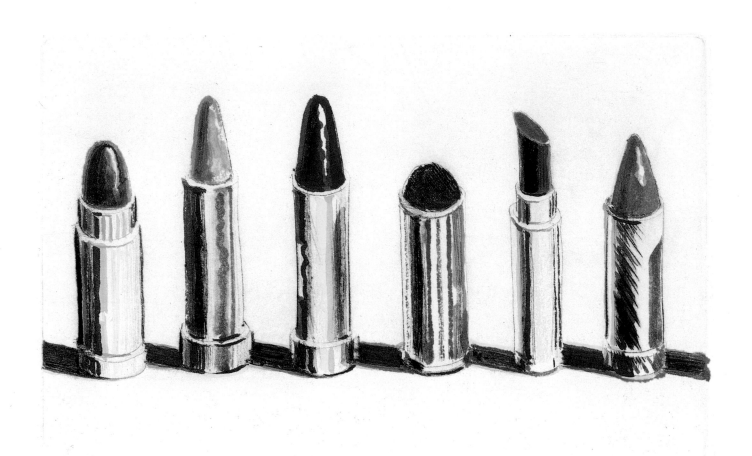

9 / 15

Lipsticks 1988
watercolor over drypoint etching
4" x 6"

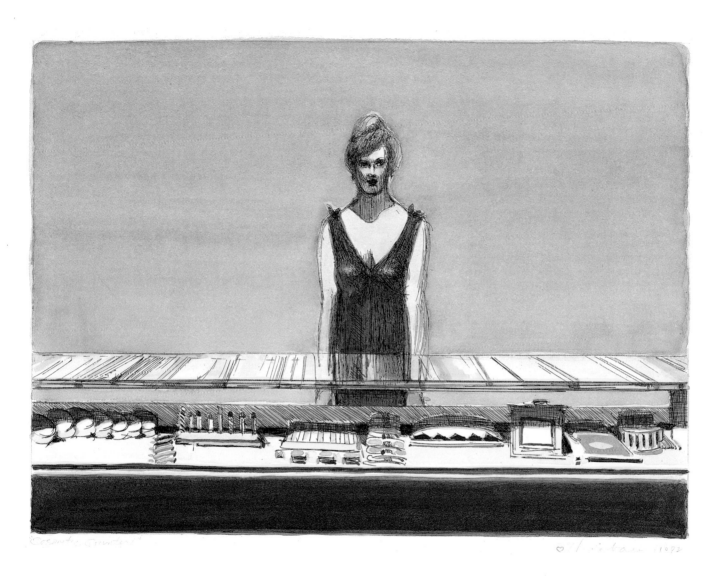

Cosmetic Counter 1982
watercolor over hard-ground etching
9" x 12"

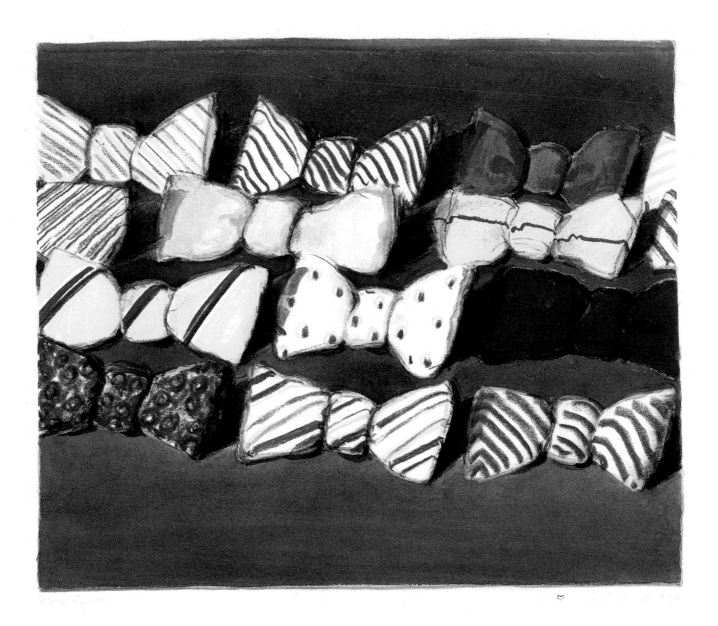

Bow Rows 1990
watercolor over lithograph
12" x 14"

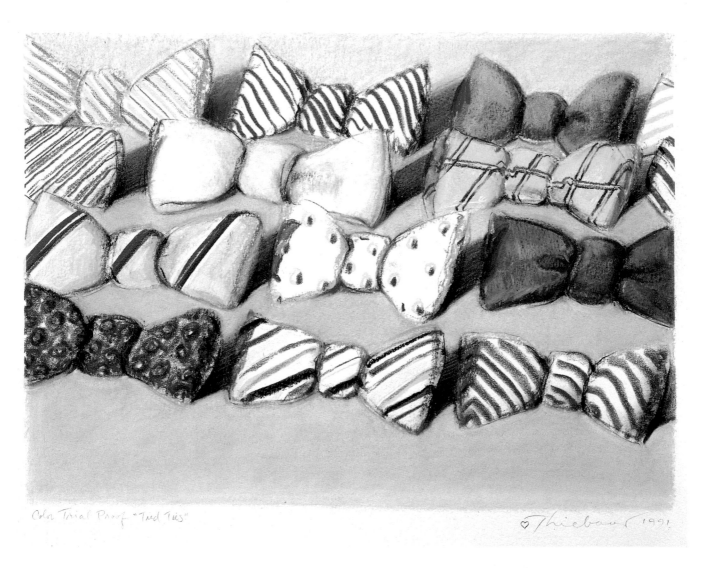

Color Trial Proof "Tied Ties"

♡Thiebaud 1991

Tied Ties 1991
pastel and charcoal over lithograph
12" x 14"
Collection of Nan Tucker McEvoy

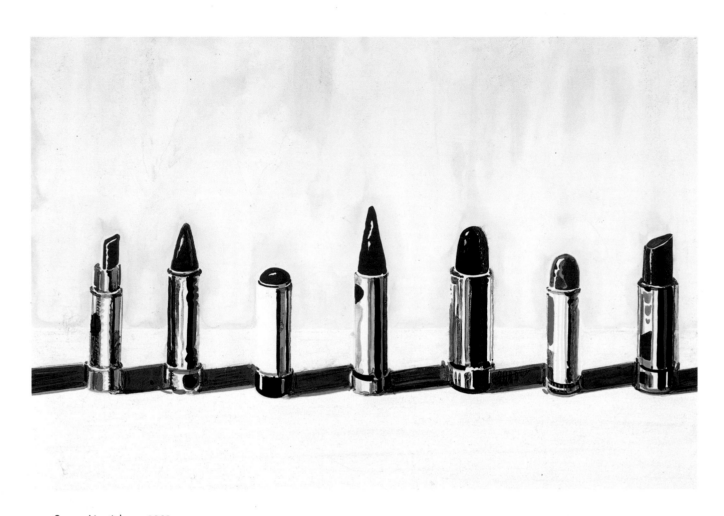

Seven Lipsticks　1991
watercolor over silkscreen
12″ x 17½″

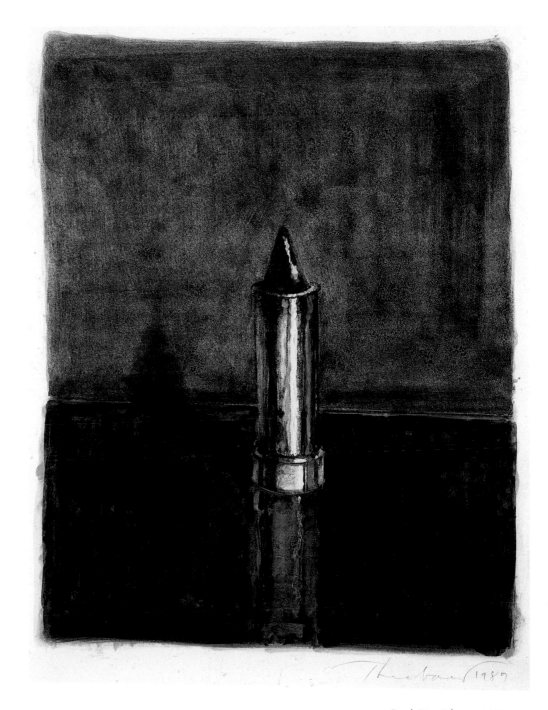

Dark Lipstick 1989
watercolor over monotype
8″ x 7″
Collection of Morgan Flagg

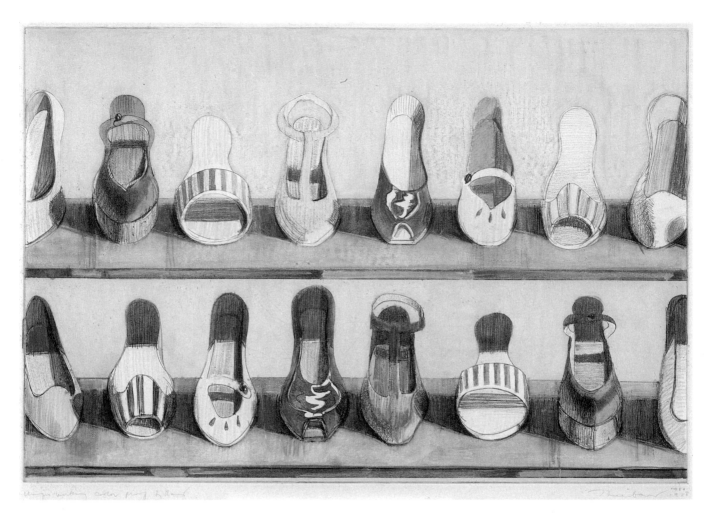

Shoe Rows 1988
colored pencil and pastel over
aquatint, spitbite, and hard-ground
etching
16" x 24"

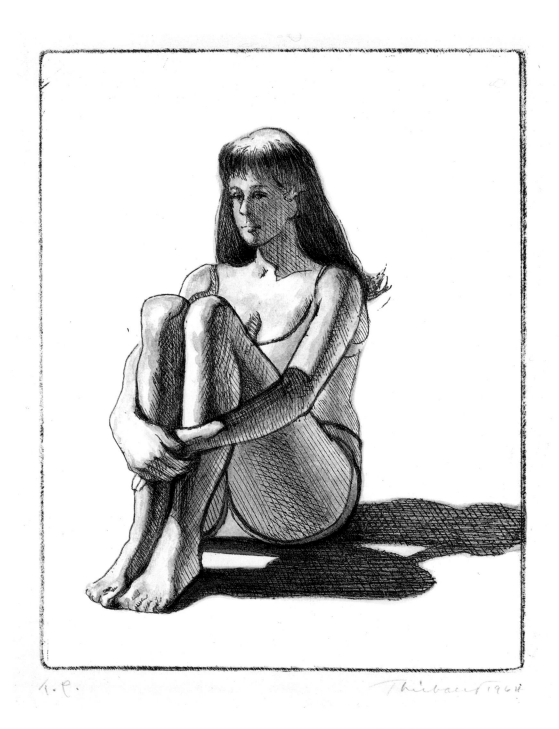

Beach Girl 1964
watercolor over hard-ground etching
7" x 5"

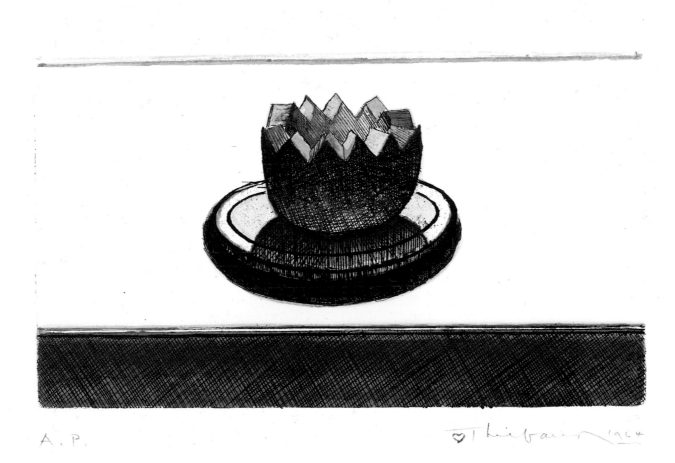

A. P. Thiebaud 1904

Cut Melon 1989
watercolor over hard-ground etching
6" x 7"

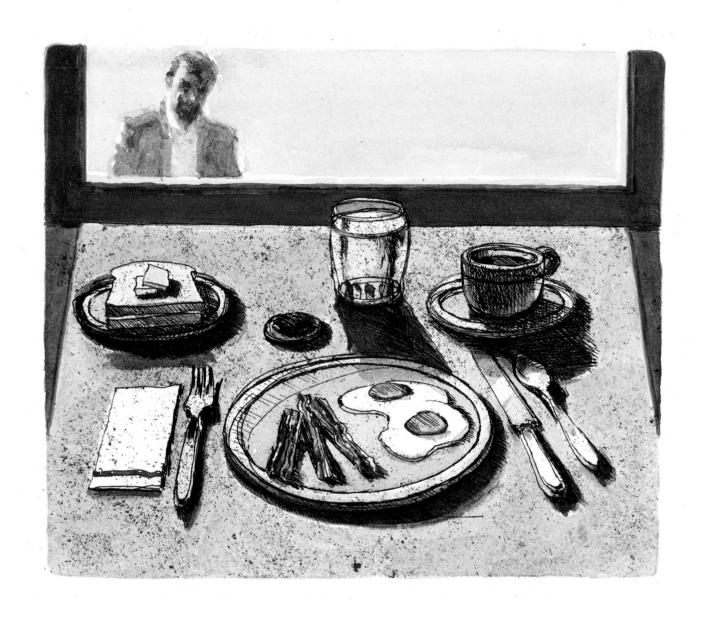

Bacon & Eggs with Man 1981
watercolor over hard-ground etching
5" x 6"

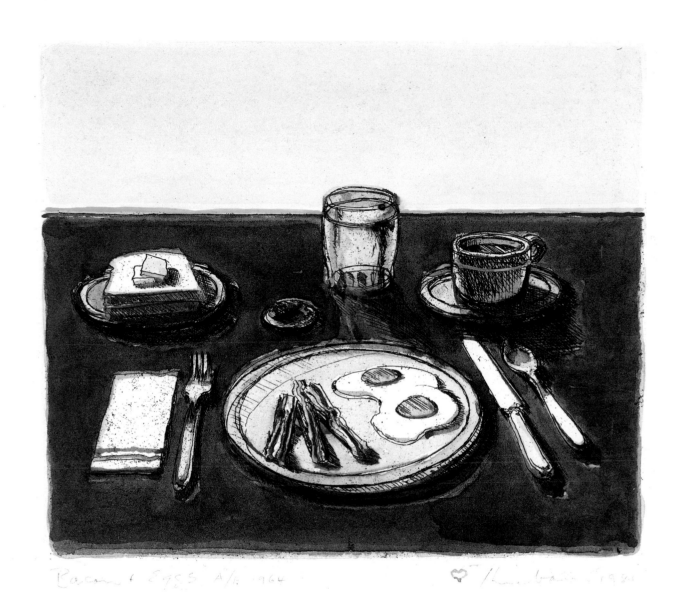

Bacon & Eggs 1981
watercolor over hard-ground etching
5" x 6"

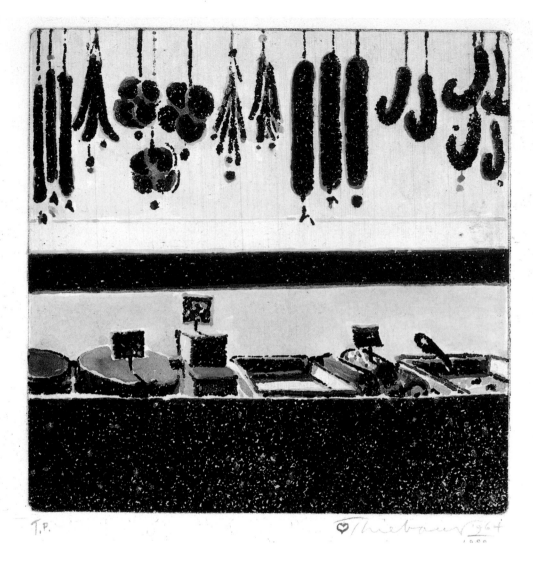

T.P. ♡Thiebaud 1964
 1989

Deli Counter 1989
watercolor over sugarlift etching
5" x 5"

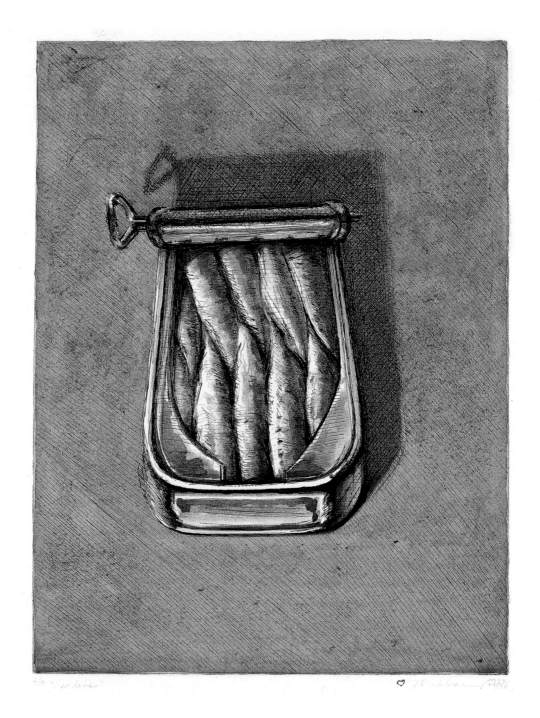

Sardines 1990
watercolor over hard-ground etching
12" x 9"

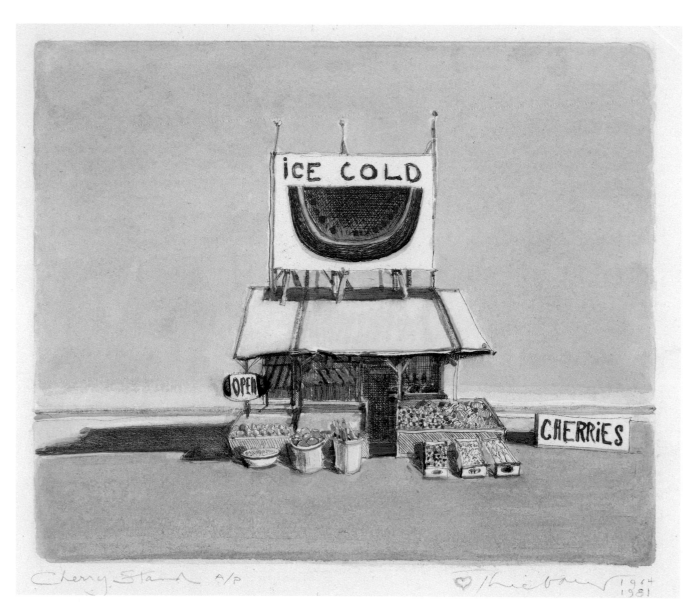

Cherry Stand A/P

Cherry Stand 1981
watercolor over hard-ground and
drypoint etching
5½" x 7"
Collection of
Mr. and Mrs. Gary M. Sumers

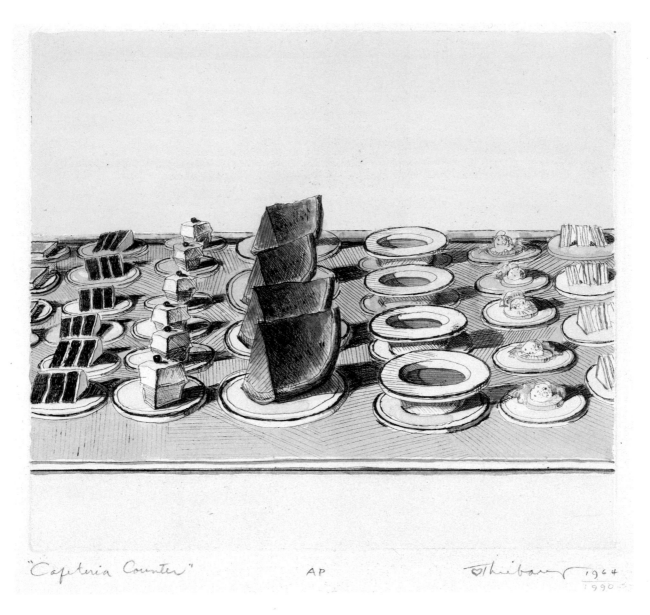

"Cafeteria Counter" AP Thiebaud 1964
 1990

Cafeteria Counter 1990
watercolor over hard-ground etching
7" x 8"

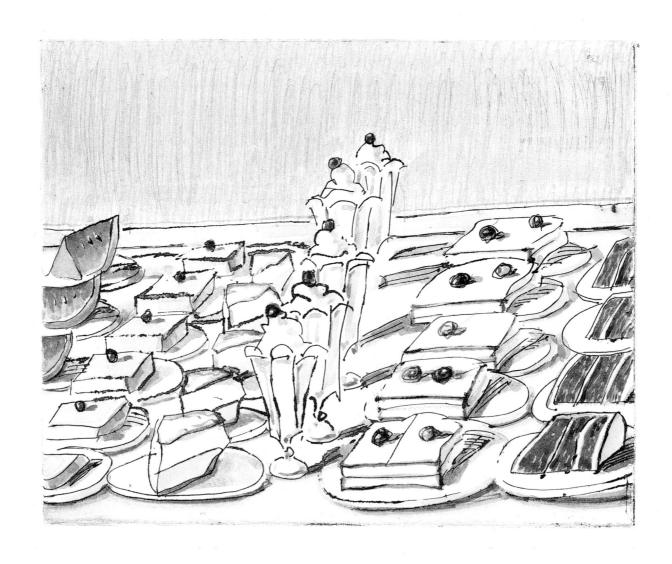

Snack Counter 1966
watercolor and graphite over
hard-ground etching
5″ x 5″

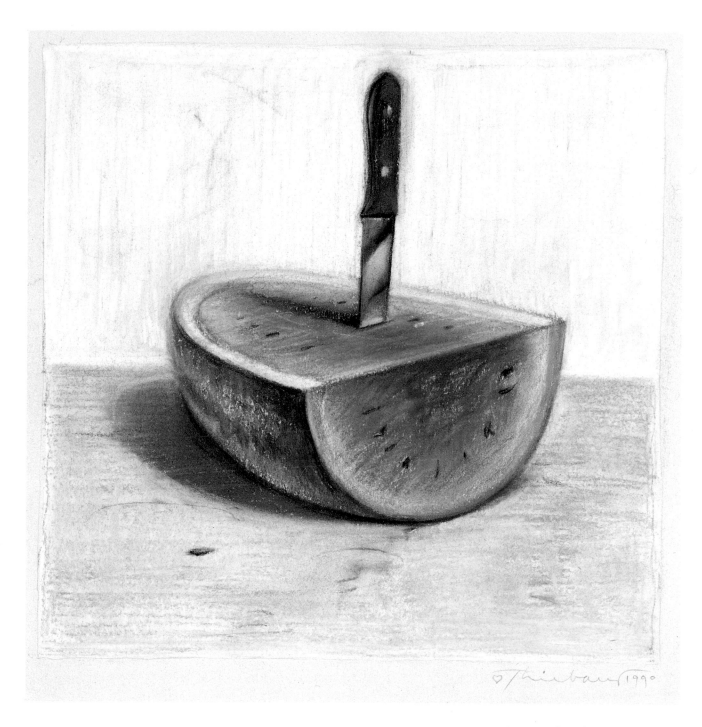

Watermelon Slice 1990
pastel and charcoal over monotype
8" x 8"

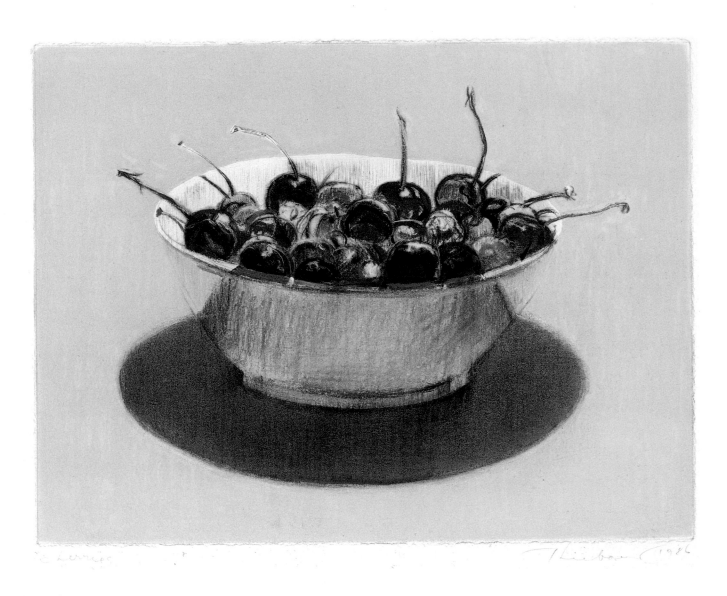

Cherries 1986
pastel over drypoint etching
9" x 12"

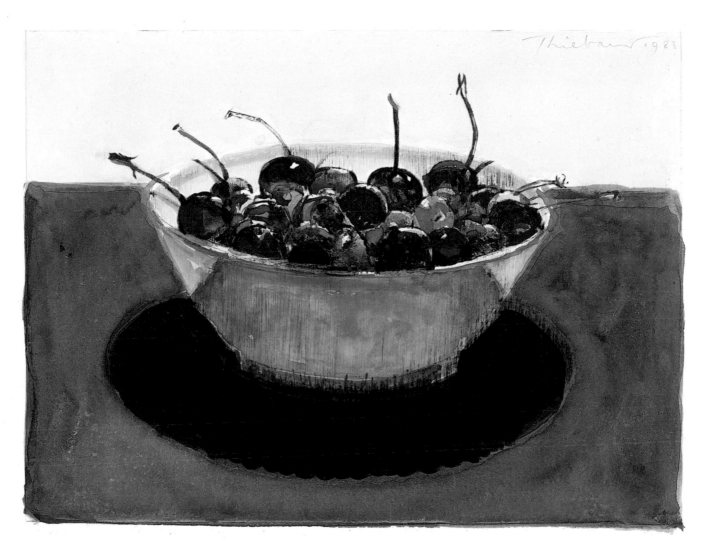

Cherry Bowl 1988
watercolor over drypoint etching
9" x 12"

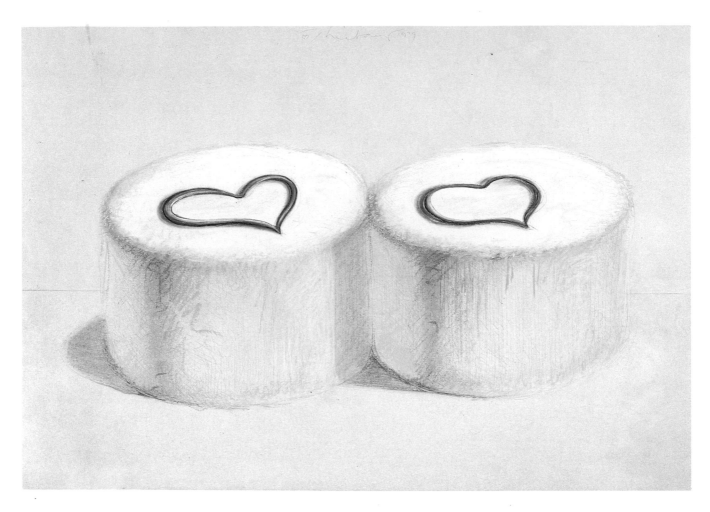

Two Cakes 1979
pastel over hard-ground etching
16″ x 23″
Collection of Betty Jean Thiebaud

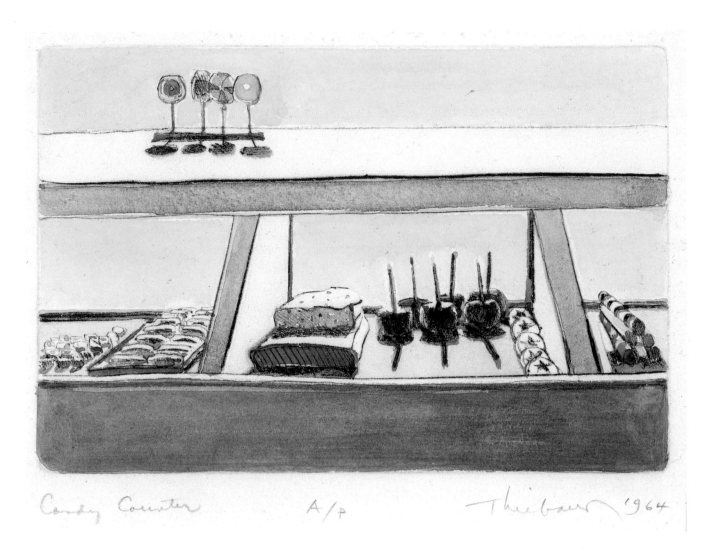

Candy Counter A/P Thiebaud 1964

Candy Counter 1964
watercolor over drypoint etching
4" x 6"

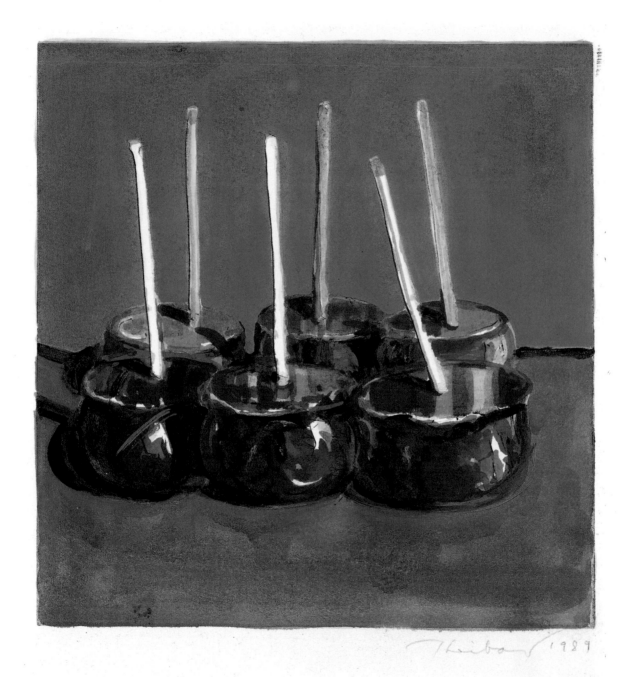

Candy Apples 1989
watercolor over monotype
8″ x 8″

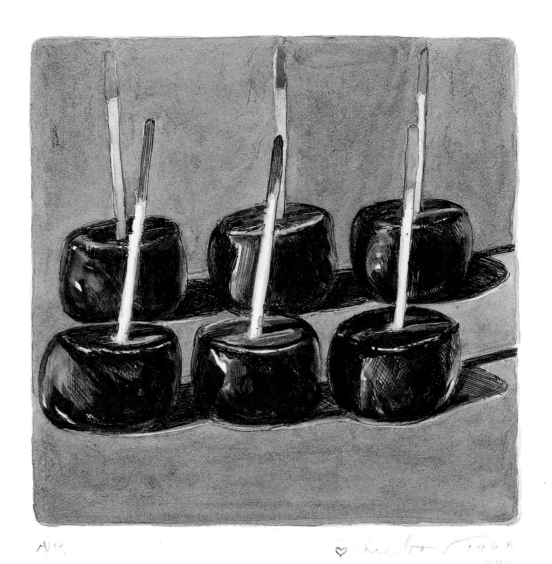

AP.

Six Candied Apples 1990
watercolor over hard-ground and
drypoint etching
5" x 5"

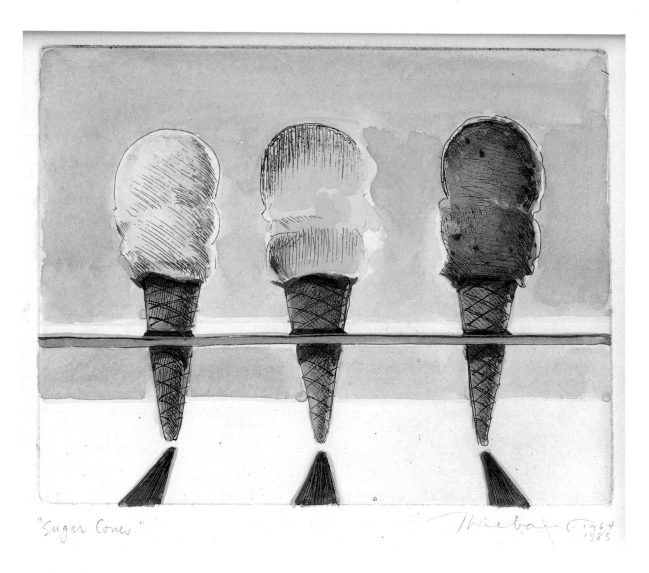

"Sugar Cones" Thiebaud 1964
 1985

Sugar Cones 1985
watercolor over hard-ground and
drypoint etching
4" x 5"
Collection of
Glenna and Charles Campbell

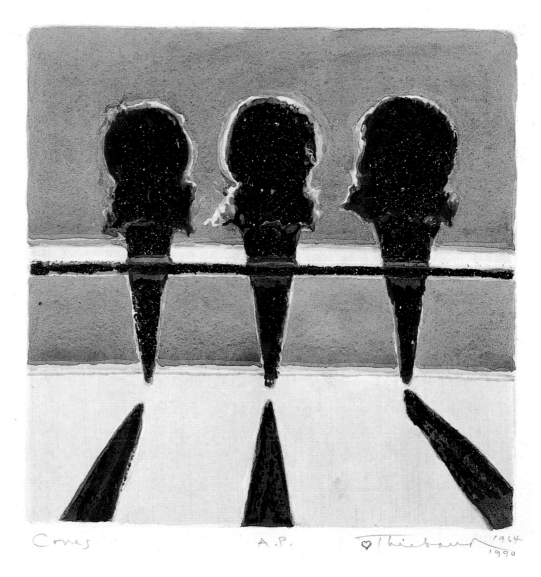

Cones A.P. Thiebaud 1964
1990

Dark Cones 1990
watercolor over sugarlift etching
5" x 5"

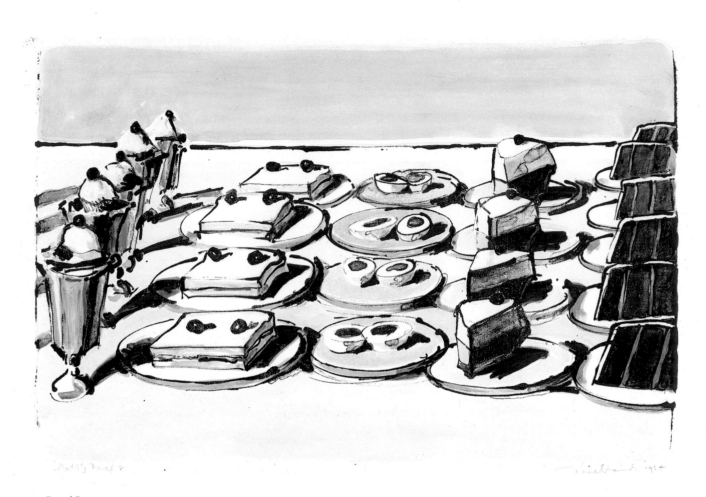

Food Rows 1964
watercolor over lithograph
14" x 21"

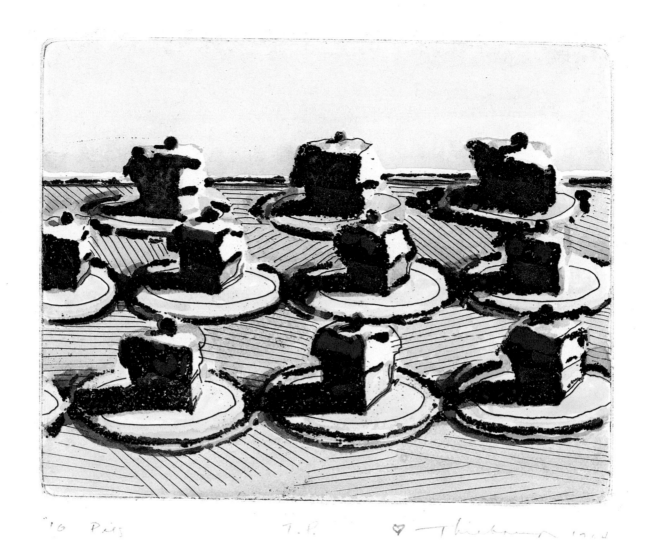

"10 Pies T.P. ♡ Thiebaud 1990

Ten Pies 1990
watercolor over sugarlift and
hard-ground etching
4" x 5"

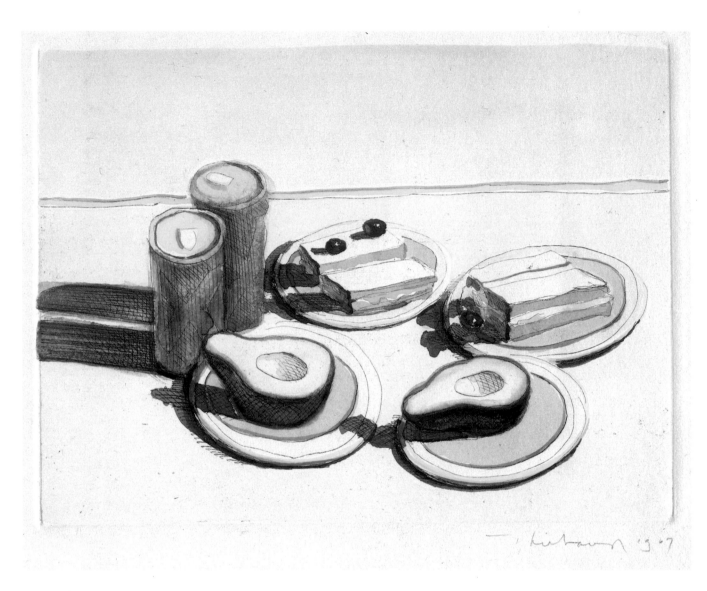

Lunch 1967
watercolor over hard-ground etching
5" x 7"
Collection of The Fine Arts Museums
of San Francisco, Achenbach
Foundation for Graphic Arts,
Hamilton-Wells Fund, 1978.1.34

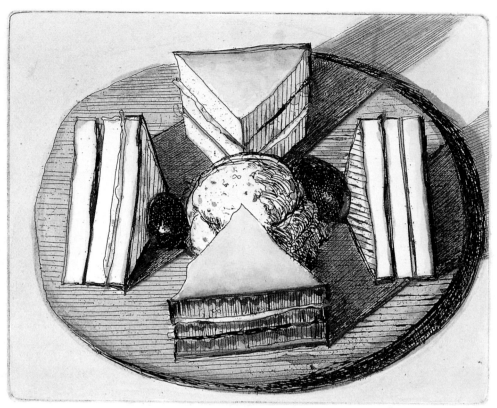

"Club Sandwich" A.P. Thiebaud '64
 1990

Club Sandwich 1990
watercolor over hard-ground and
drypoint etching
4" x 5"

49

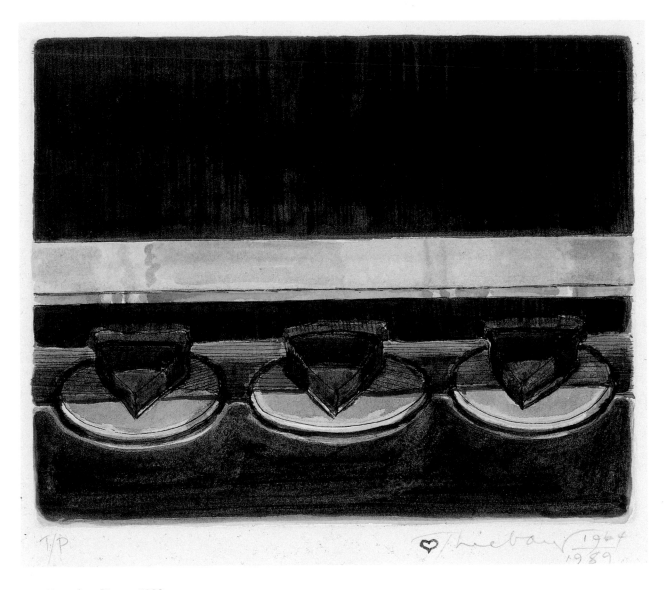

T/P

Chocolate Pies 1989
watercolor over hard-ground and
drypoint etching
4" x 5"

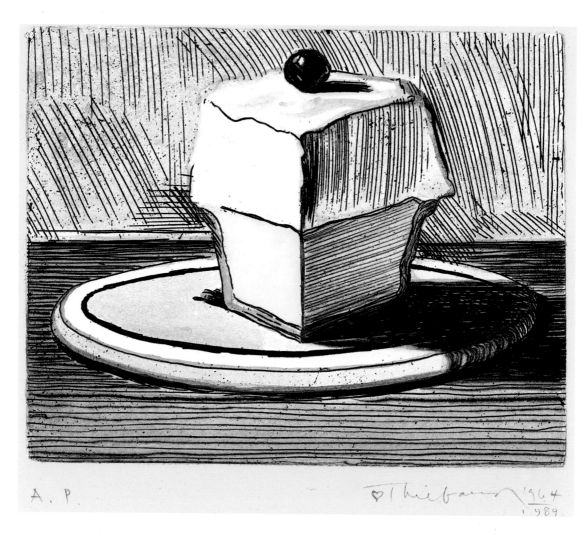

A. P.

Lemon Meringue 1989
watercolor over hard-ground and
drypoint etching
4″ x 5″

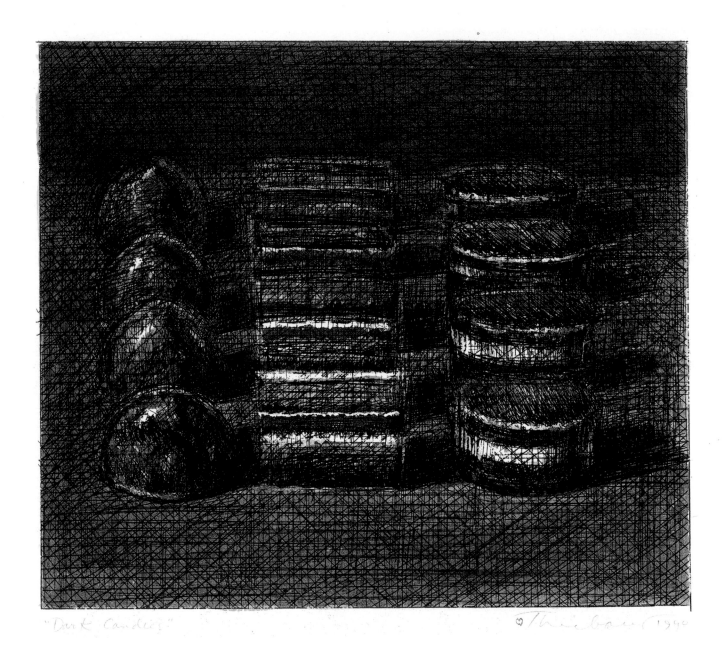

"Dark Candies" Thiebaud 1990

Dark Candies 1990
watercolor over lithograph
6" x 7"

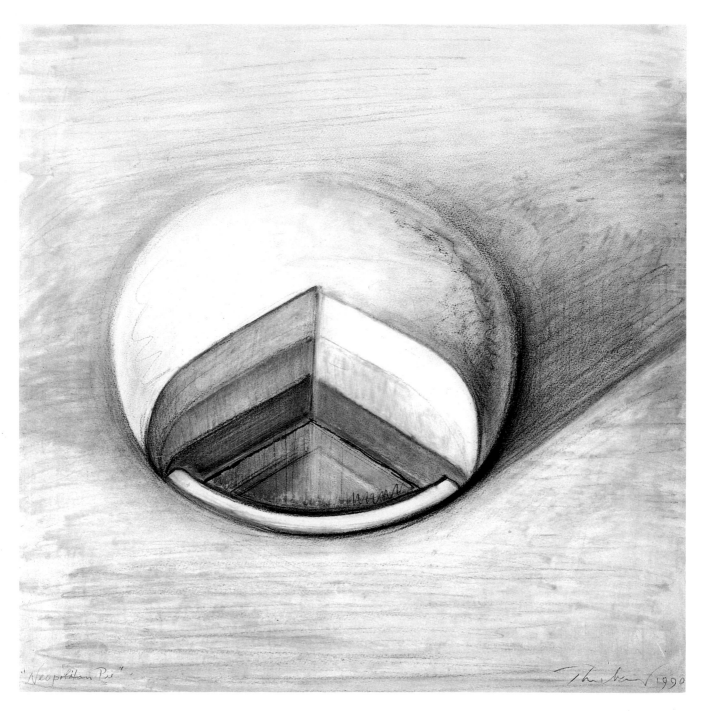

"Neapolitan Pie"

Neapolitan Pie 1990
pastel and charcoal over lithograph
19" x 19"

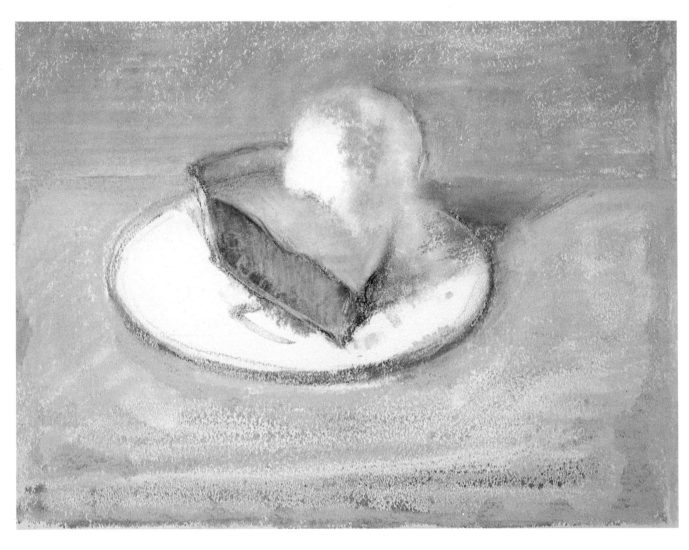

A La Mode 1991
pastel and watercolor over monotype
10¼″ x 13⅝″

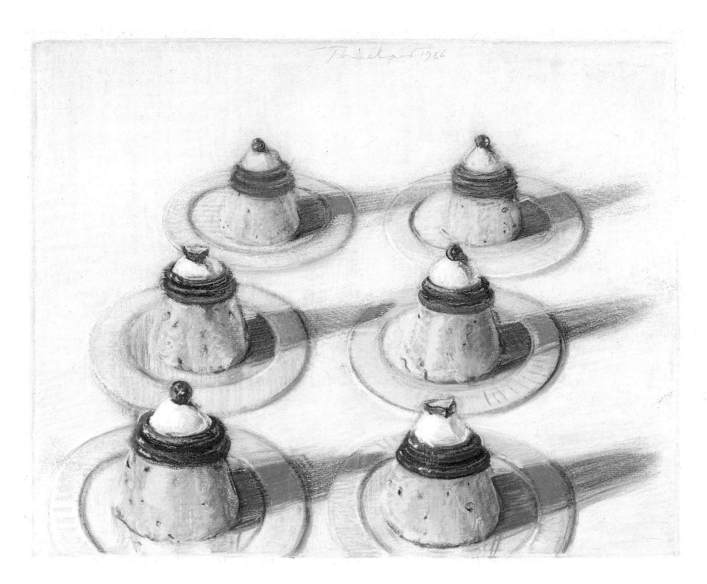

Italian Desserts 1986
pastel over soft-ground etching
16" x 20"

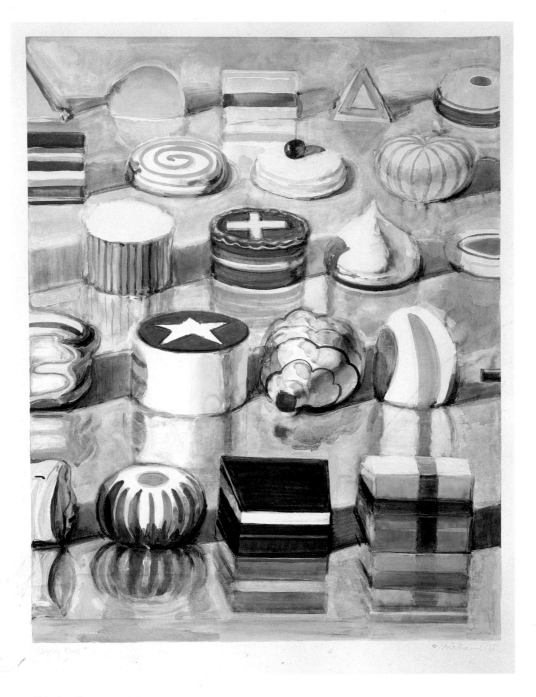

Display Rows 1991
watercolor, acrylic, and
casein over lithograph
29" x 23"

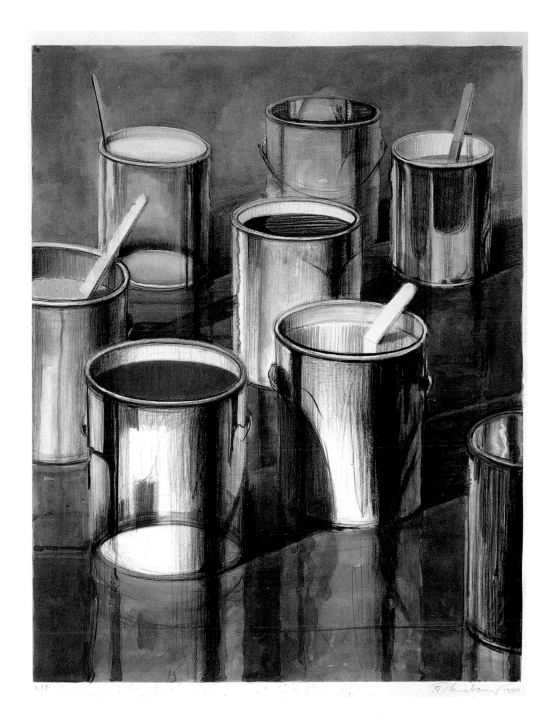

Paint Cans 1990
watercolor and colored pencil
over lithograph
30" x 23"

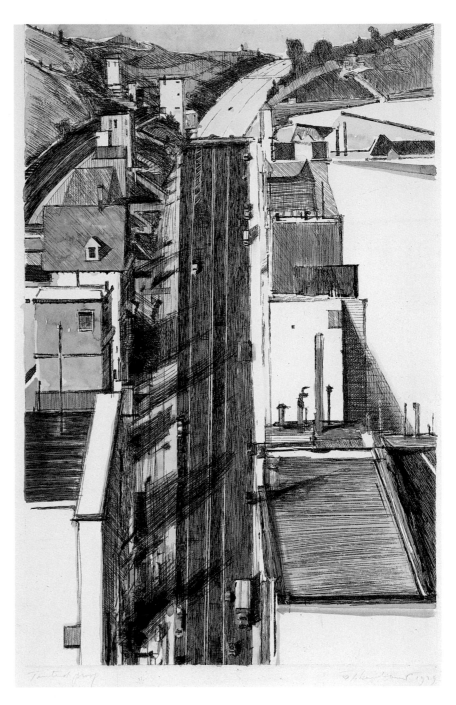

Downgrade 1979
watercolor over hard-ground etching
20" x 13"

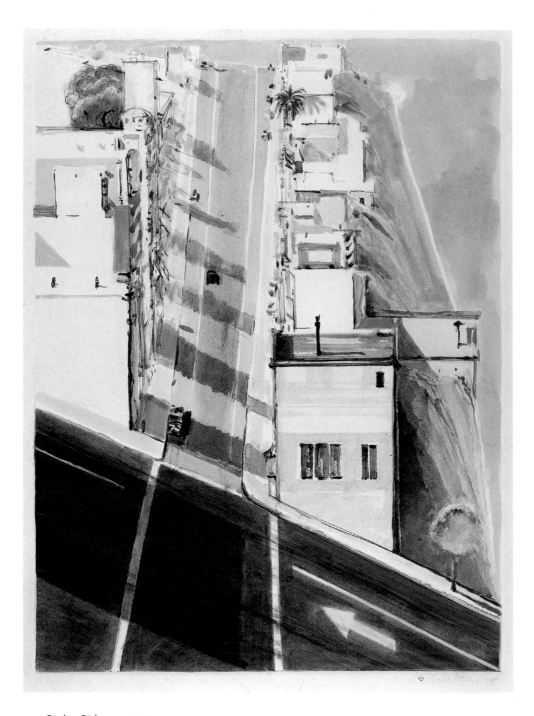

Ripley Ridge 1977
watercolor over monotype
24″ x 17½″

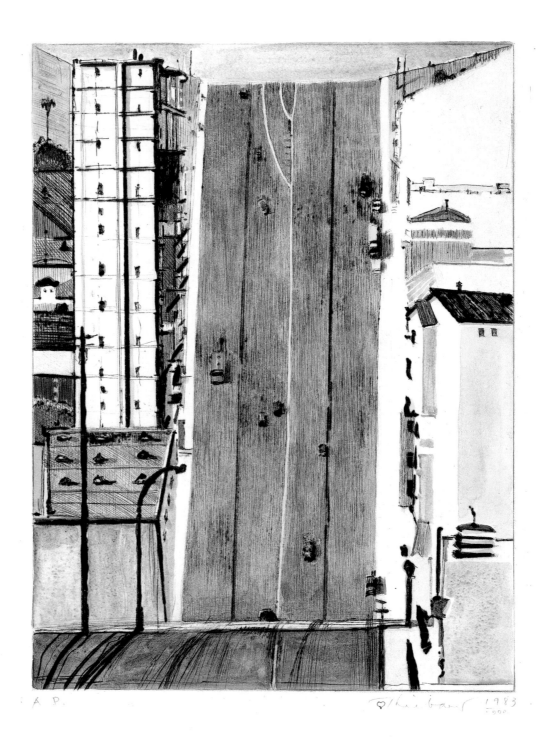

A.P. Thiebaud 1983

Wide Downstreet 1990
watercolor over drypoint etching
12" x 9"

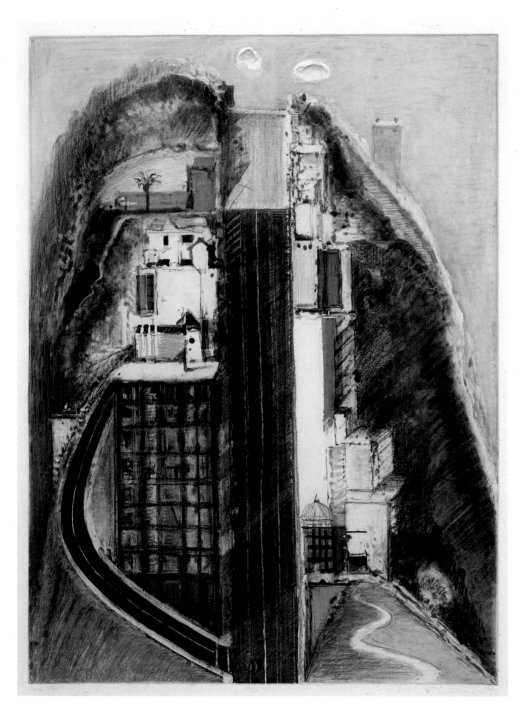

Steep Street (color) 1989
pastel over spitbite aquatint and
drypoint etching
30" x 22"

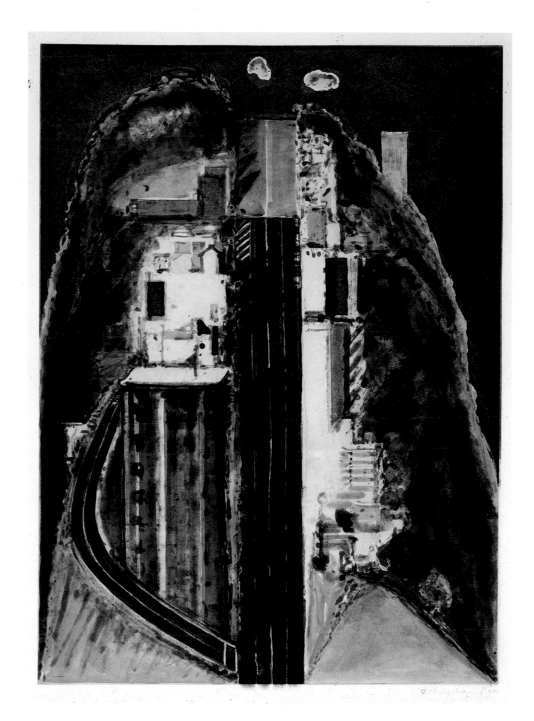

Steep Street (black and white) 1989
watercolor over spitbite aquatint
and drypoint etching
30" x 22"

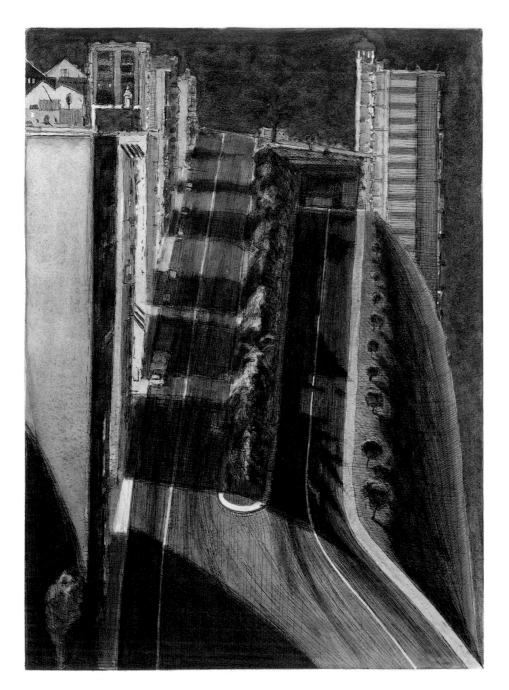

Night Ridge 1988
watercolor over hard-ground and
drypoint etching
14" x 10"
Collection of
Deedee and Burton McMurty

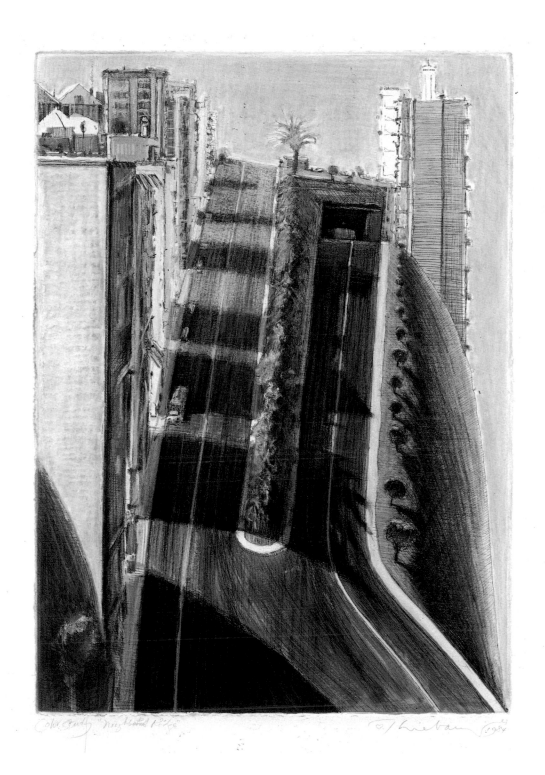

Neighborhood Ridge 1984
pastel over hard-ground and
drypoint etching
14" x 10"
Collection of
Gretchen and John Berggruen

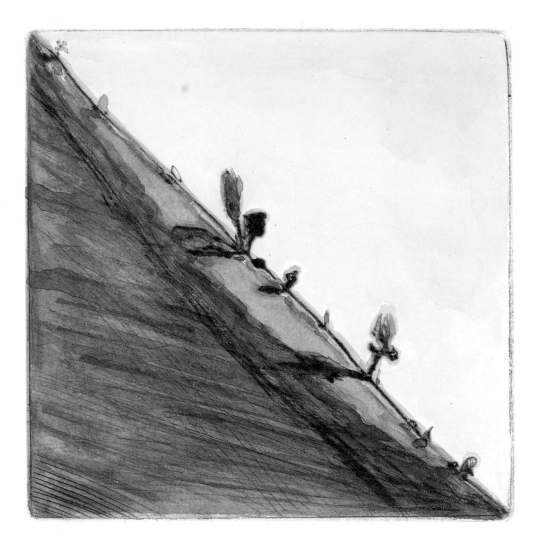

Steep Ridge 1968
watercolor over drypoint etching
4" x 4"

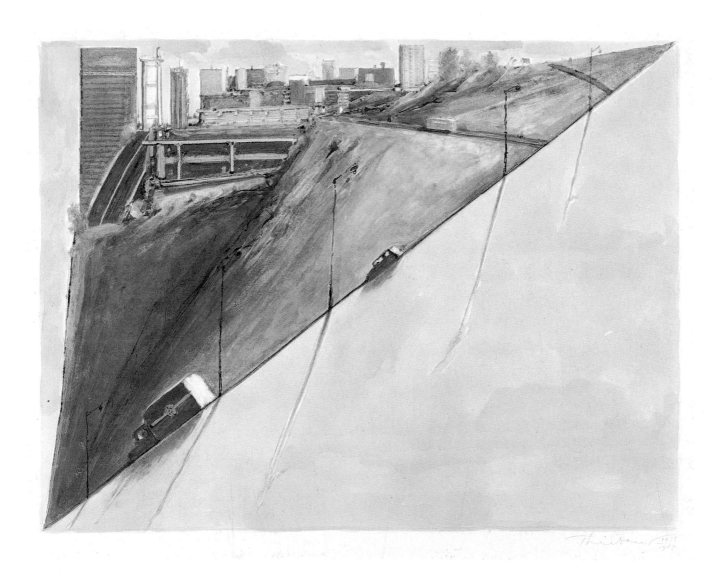

Diagonal Ridge 1989
watercolor over monotype
17½" x 23"

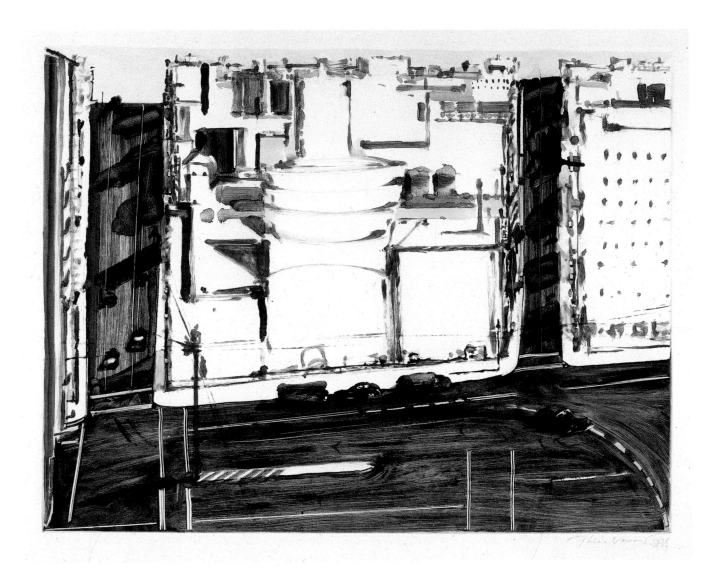

Urban Square 1989
watercolor over monotype
17½" x 23"

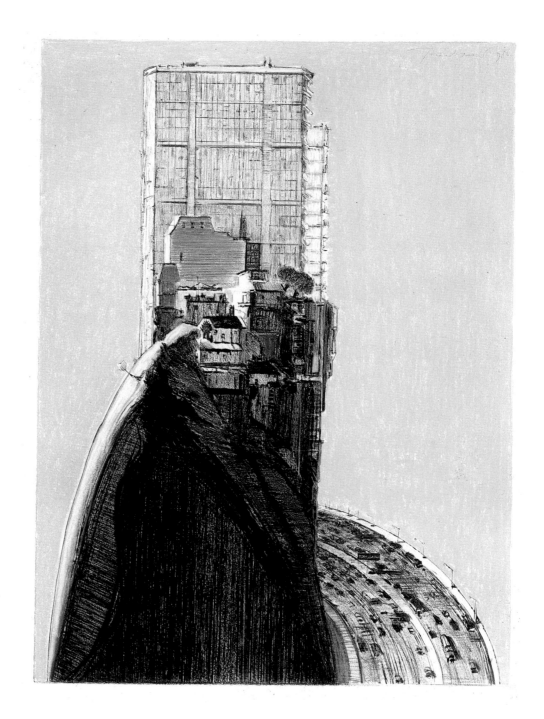

Apartment Hill 1980
pastel over drypoint etching
24" x 18"

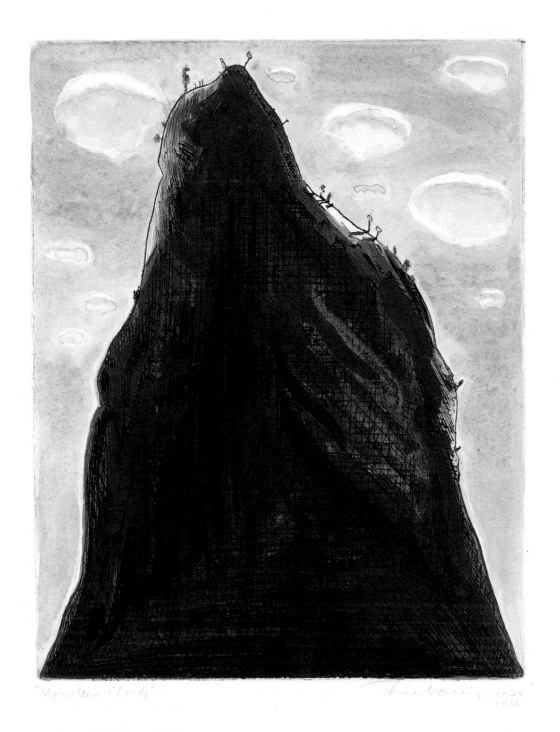

Mountain Clouds 1986
watercolor over hard-ground and
drypoint etching
7" x 5½"

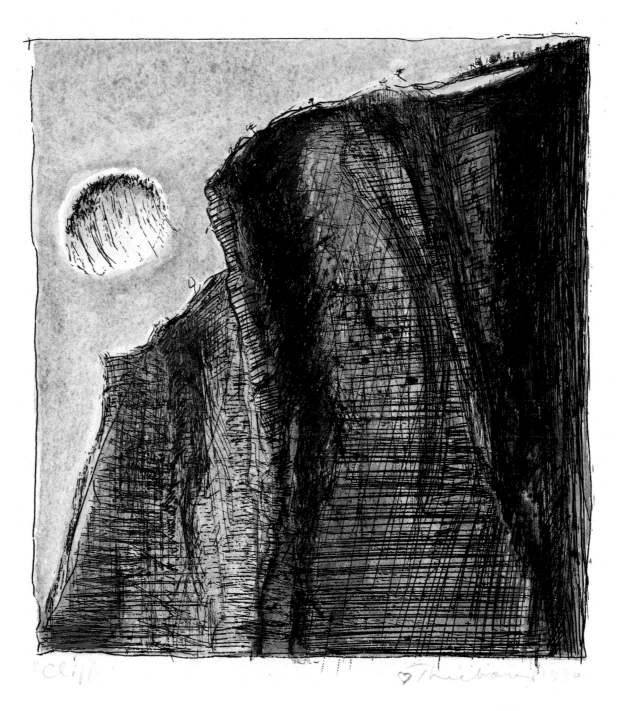

"Cliff"

Cliffs 1990
watercolor over lithograph
4½" x 4"

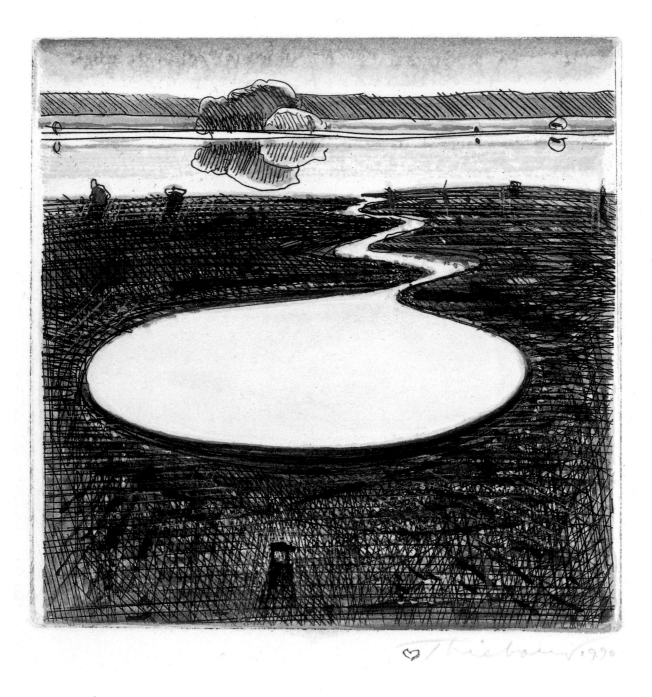

Farm Pond 1990
watercolor over hard-ground etching
4" x 4"

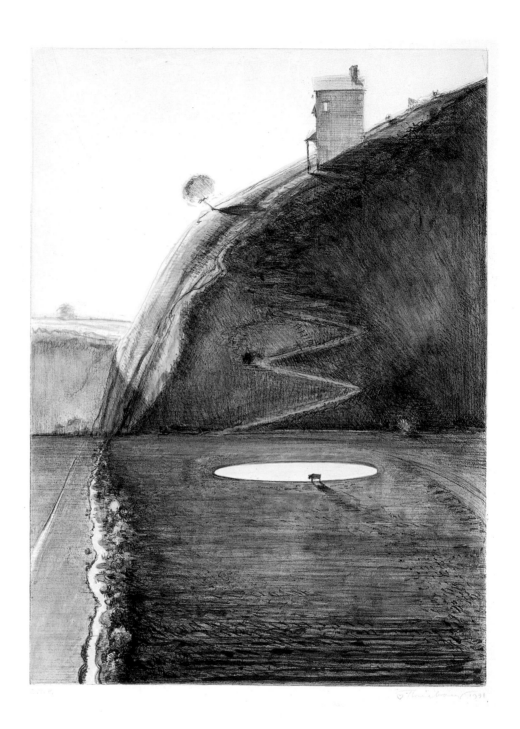

Valley Farm 1991
watercolor over aquatint and
soft-ground etching
22" x 16"

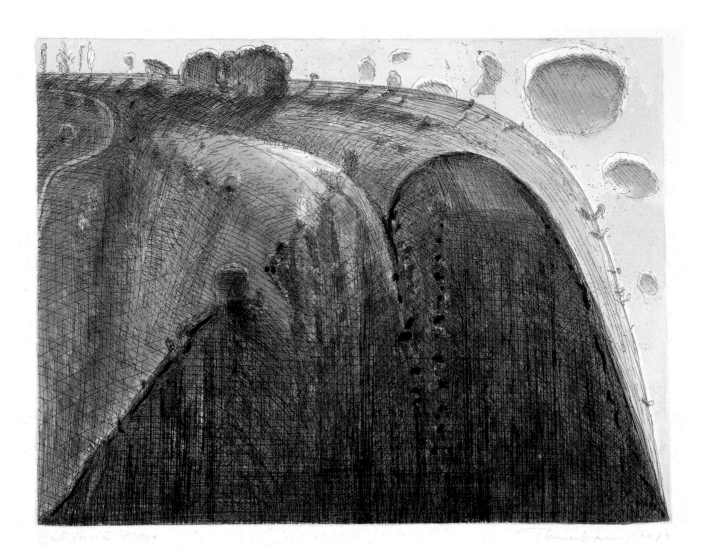

California Ridge 1987
watercolor over hard-ground etching
9" x 11½"

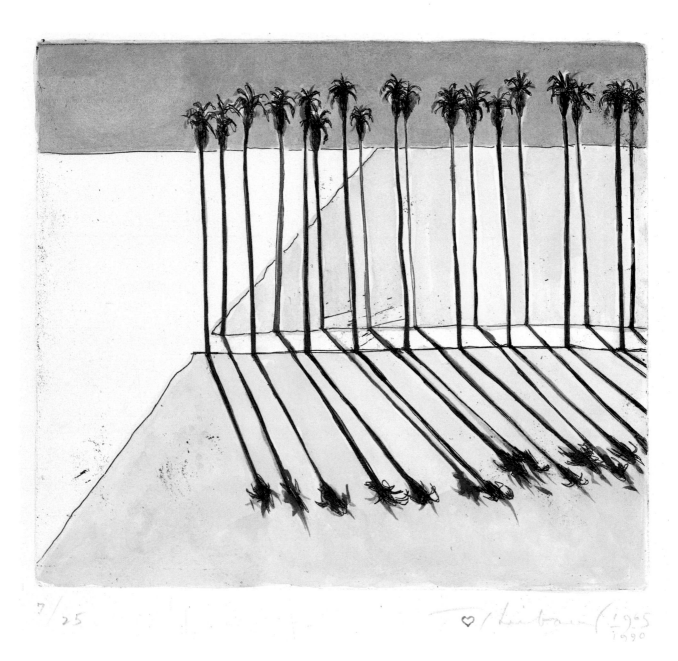

7/25

Palm Road 1990
watercolor over hard-ground etching
6" x 7"

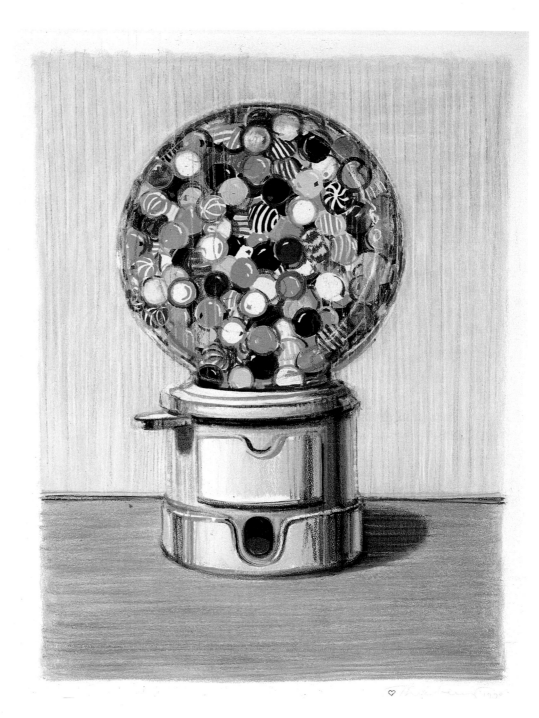

Jawbreaker Machine 1990
watercolor, pastel, and gouache
over linocut
22" x 17"
Collection of Mr. and Mrs. Allan Stone

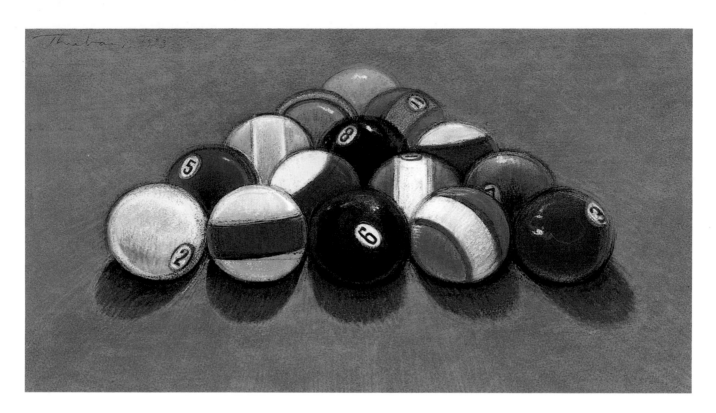

Game Balls 1991
pastel over silkscreen
11" x 20"

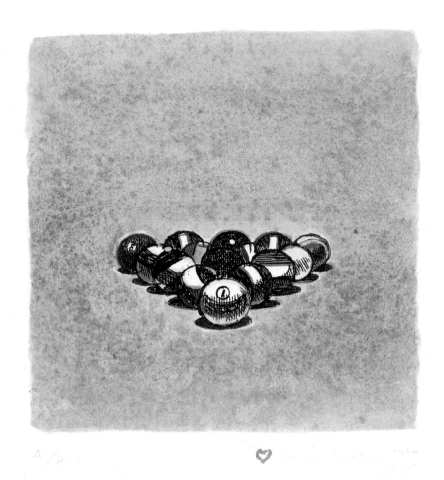

Pool Balls 1988
watercolor over hard-ground etching
4" x 4"

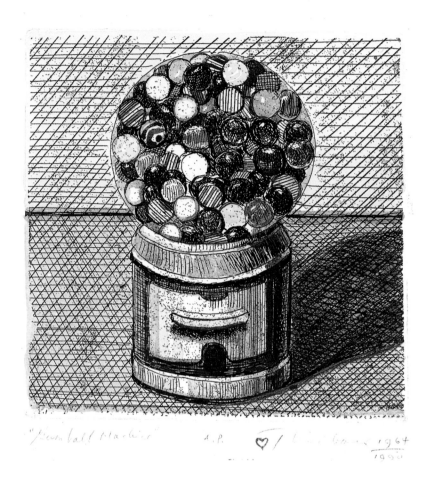

"Gumball Machine" A.P. ♡/ Wayne Thiebaud 1964
1990

Gumball Machine 1990
watercolor over hard-ground etching
4″ x 4″

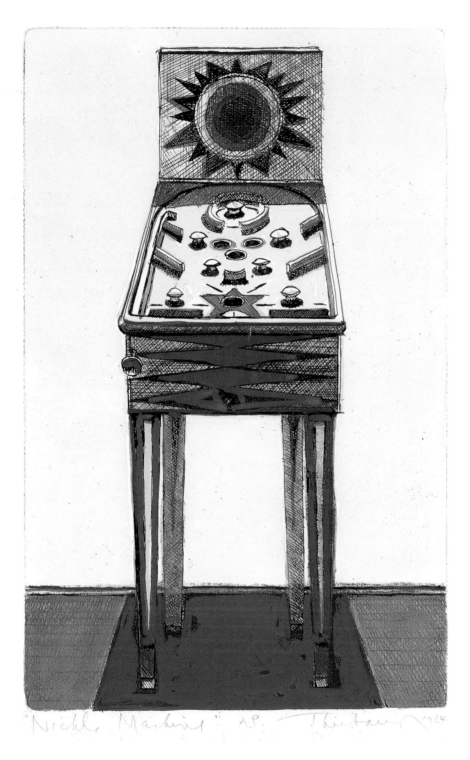

"Nickl, Machine" A.P. Thiebaud 1984

Nickle Machine 1982
watercolor over hard-ground etching
8″ x 5″

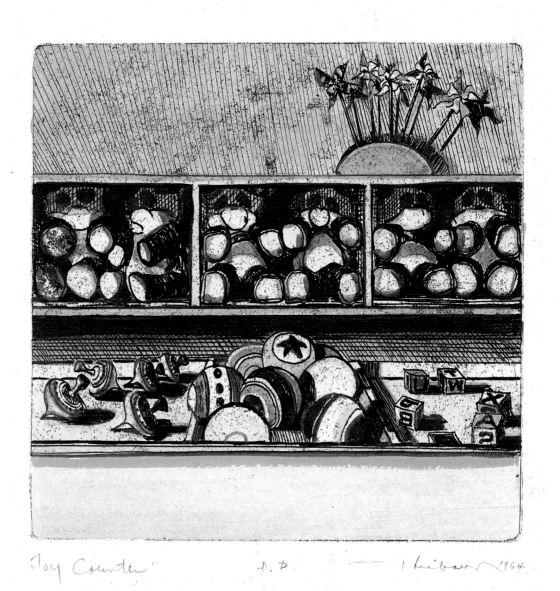

"Toy Counter" A. P. Thiebaud 1964

Toy Counter 1964
watercolor over hard-ground etching
5" x 5"

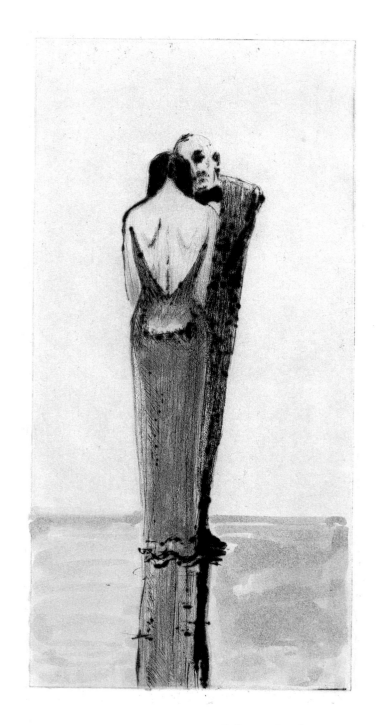

Ballroom Couple 1989
watercolor over drypoint etching
10" x 5"

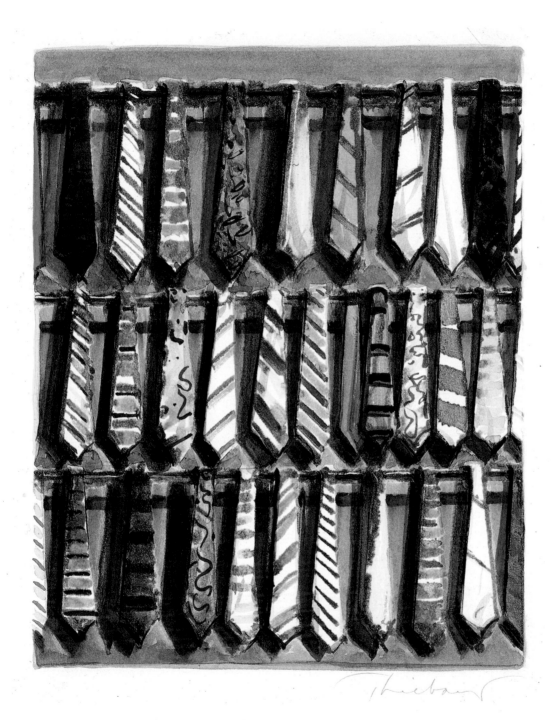

Row of Ties 1977
watercolor over monotype
10″ x 8″

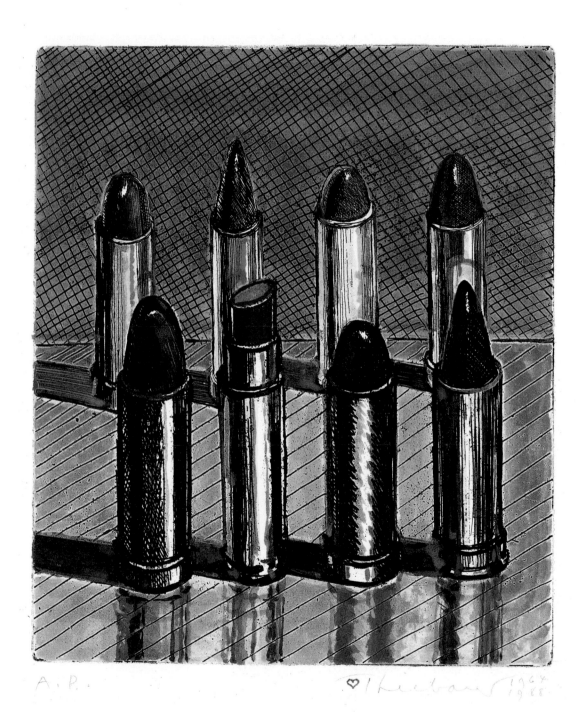

A.P.

Eight Lipsticks 1988
watercolor over hard-ground etching
7" x 6"

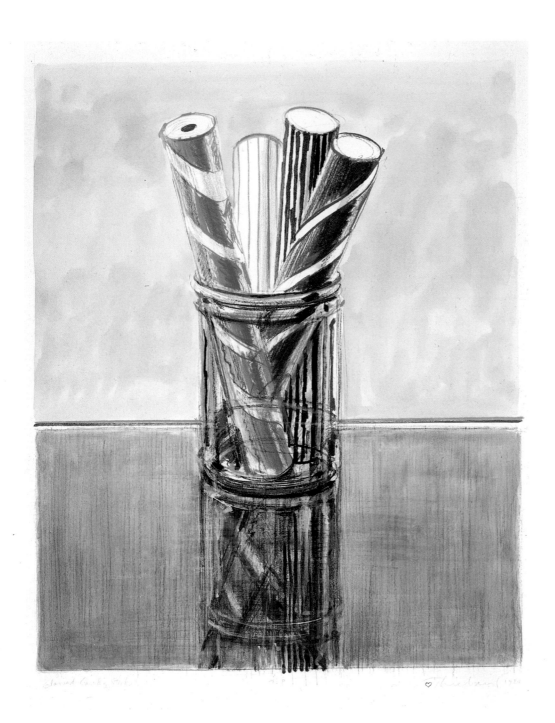

Glass Candy Sticks 1980
watercolor and colored pencil
over lithograph
21″ x 17″

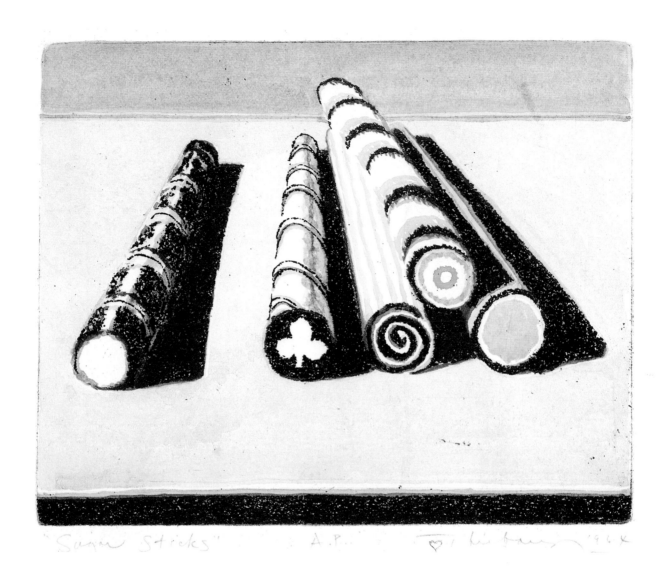

"Sugar Sticks" A.P. [signature] '96

Sugar Sticks 1990
watercolor over sugarlift etching
5" x 6"

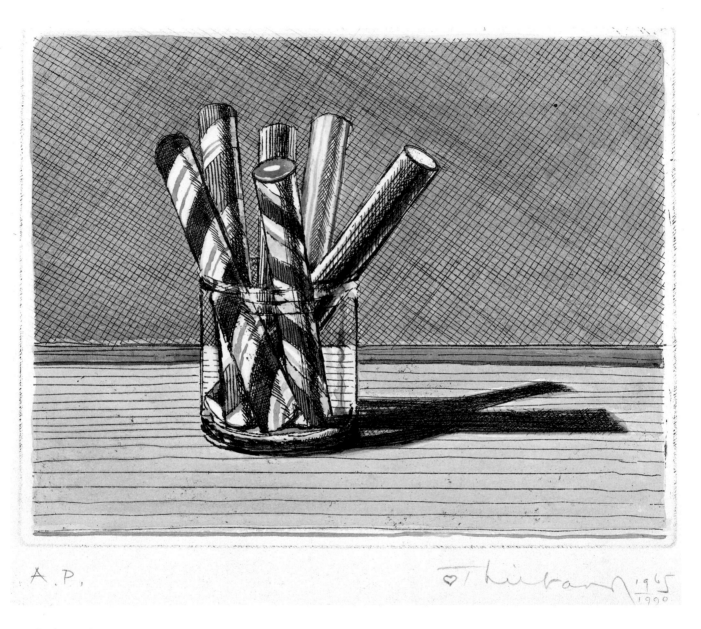

A. P.

Sticks in a Jar 1990
watercolor over hard-ground etching
5½″ x 7″
Collection of E. J. Russell

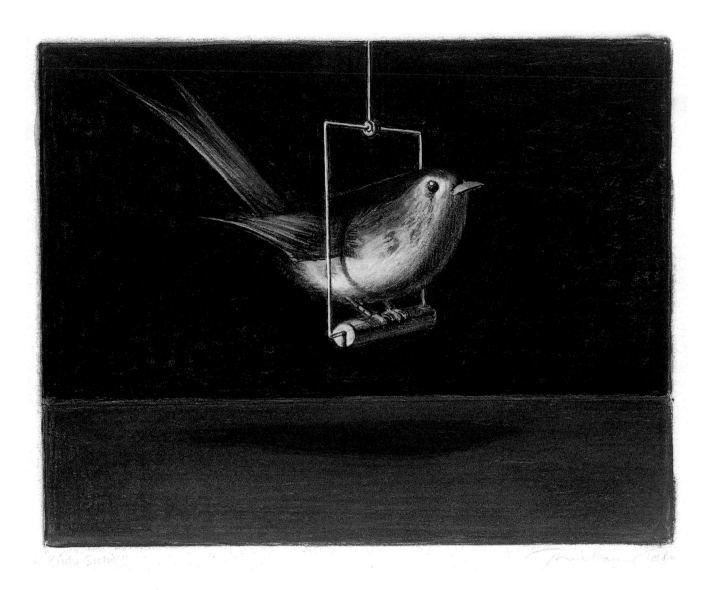

Bird in Swing 1986
pastel over soft-ground etching
10″ x 12½″

The Thiebaud Papers

Bill Berkson

Little else in art makes as much sense as taking something real and making a picture of it. There is some malice in the fact that an image thus put forth can remain both paradoxical and clear. The paradox, after all, is a lifelikeness we have no reason to expect from the formalities of the art. This vivid apparition, soon recognized, develops and insists beyond its occasion and becomes decisive: simply enough, you can see it there and wonder at it, again and again.

Wayne Thiebaud's images have that sort of quick and insistently baffling visibility. They are bright and objective, and they never let you off the hook as to what is really being shown. They are eminently formal and "put," with resonance extending from each thing's being just where you see it, from its distinct placement. Thiebaud is a realist in every shading of the term. The sociable character his art projects is that of a complex professional with a justly popular appeal, just as Chardin was, and Matisse. In a way, his subjects are no more complicated or absurd than the standard realist's stock-in-trade of problems inherent in fixing a believable image on a discrete surface: what will stick or slip away? how much detail can be seen and grasped, and how much of that is manageable, in the moment-to-moment looking and limning?

Fairfield Porter once remarked that what counts in abstract painting is the subject matter, while in realism a picture's abstract, formal qualities often deepen our interest past what the obvious subject matter seems to intend. Thiebaud's realism asserts abstractness so as not to encumber itself with the formulas of either convenient senti- ment or too easily apprehensible design. The concomitant tensions among his forms issue their own interpretations. It could be noted, for example, that he has car-

ried on a love affair with the ellipse as passionate and fructifying as Josef Albers's with the square. His shadows are Platonic; they refer to another world, close but parallel, of alternate forms, and, as characters, more actual at times than the solid objects themselves.

From the everyday world Thiebaud takes those incidentals that vision generally casts aside and relocates them as sudden disclosures of fact observed out of flux. The odd motif he delights in—sardines in a can, billiard balls racked up just right, a Brasilia of ornate cakes spread out under fluorescent glare—registers spatially as at once blunt and dubious. It is as if, being scrutinized all of a sudden from a perspective disconcertingly like its own (the anthill perceived at some distance by an ant), a peculiar thing will appear forever after on edge, unsure of its whereabouts. Thiebaud suggests that things are a little beside themselves in situational time, because the situation, like pictorial space, is controvertible.

A single motif, in Thiebaud's hands, can be transformed in many ways in different processes over time. For instance, the chubby little bird on a swing seems to have gone from a drawing in the mid-1960s to pastel and through various types of etching without ever appearing in the repertoire of Thiebaud's work on canvas. The present version is pastel over a previous soft-ground etching. As ever, we see the invented creature on tail-up alert in three-quarter view straining from its perch, the shadow beneath like the flash of another bird (perhaps of more certain lineage) on the wing.

The images in Thiebaud's paintings partake of the slippery character of paint, along with the tactility of the brushed-up surface. In the graphics, the range of sensation is different, more delicate, statelier, and more succinct. Smears are replaced by blots, halating contours by sharp or squiggly incisions, smooth, fat, horizontal strokes by crosshatchings and stark reaches of bare white sheet. Taking a discarded or trial proof of a print one step further by adding colors and adjusting details is more than a matter of mere touching up or busywork: the modified object elaborates upon a set theme and reveals aspects that previously might have been omitted. Here Thiebaud's professionalism gets to stretch out and celebrate itself. Like the oil paintings, these works on paper are task-specific, using the nature of whichever medium—or more specifically, medium over medium—to show us more about the subject at hand.

The paper sheets, big and small, offer an attentive spaciousness, then the zeroings-in on particulars that light up the whole. Where Thiebaud redoubles his attentions — working over a print with watercolor or pastel — a plenitude of virtuoso subtleties results. The speed and density of etched lines are modulated by a fresh coat of lapidary color. Where watercolor meets sugarlift, as in *Deli Counter* and *Sugar Cones*, the original granular blacks extrude gravely amid their new tonal settings. In three separate pastel reworkings of *Steep Street* (a spitbite-etching motif first conjured up in watercolors), not just the light has changed (from day to dusk and back again) but minute details of the hillside view have undergone shifts of emphasis or, in some cases, utter deletion. Yet the basic image stays intact: is it urban purgatory or a Breughel-ish cornucopia? Whichever, Thiebaud has nudged the unplanned, hoydenish components of his toy city (a fair designation of San Francisco, where he keeps a second home and studio) into a convincing shrine.

Thiebaud began making his composite cityscapes in the early 1970s. Through the 1960s, he had been acknowledged as much for his depictions of rigidly posed human figures as for his still-lifes. (*Girl with Ice Cream Cone,* recapitulated here in a watercolored version of the print he made with Kathan Brown at her Berkeley studio in 1964, was probably his best-known image at the time.) But, toward the end of that decade, he stopped painting the figure, feeling dissatisfied with the results. Recently, he has resumed putting images of people into his pictures, but this time with a storytelling edge that his floodlit 1960s settings had disallowed. The most unexpected of these new pictures is *Dancing Couple,* a heavy-set, mustachioed man and a slender young woman in a light blue gown locked upright together in what appears to be a frozen instant of mutual contrition. Part of a projected series of narrative images, the washed-over drypoint print recalls similarly chilling moments in the pictures of Edvard Munch. Its closely mottled nostalgia — the couple's 1920s-style formal attire and chromo gestures lend the work a period look — is countered by the near-sculptural firmness of an attenuated wedge formed by the distracted pair, for which their reflection on the buff-colored ballroom floor makes a witty kind of pedestal. How did these remnants from the throes of Jazz Age melodrama insinuate themselves into Thiebaud's contemporary repertoire? One answer might be found among the artist's memories from his brief career in the 1940s as a stage designer; another might refer to his abiding admiration for Munch as well as for that other master of the

erotic charge set crackling in parlor contexts, Balthus. Be that as it may, the image signals a surprising advance in Thiebaud's art towards more variable psychological pressures, while leaving the symbolic message as ever open.

"Inquiry," as Thiebaud uses the word, is the gentleman-scholar's term for what another sort of artist—Mondrian, for one—would call his "search." In his worked-over prints, with a studio ecologist's proviso of avoiding paper waste, Thiebaud shows less interest in going himself one better than in simply continuing, refining as he goes, and getting more deeply into his process. (It's pertinent that, at seventy, he shows no signs of let-up in this regard.) In art, the true professional knows there is no finished business, just the next interplay of conception and handling. The precise terms of Thiebaud's vision are such that each juncture demands its own sense of provisionality as much as hieroglyphic completion. His clarities exemplify present-day consciousness threading its way through the multitudinous and ordinarily quizzical arithmetic of material life.

Parts of this essay have been adapted from the author's text for the Arts Club of Chicago's exhibition catalogue, Wayne Thiebaud: Works on Paper, *1987.*

Illuminated Impressions:
A Brief History of the Hand Colored Print

Robert Flynn Johnson

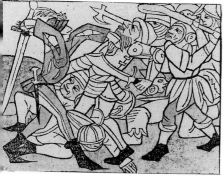

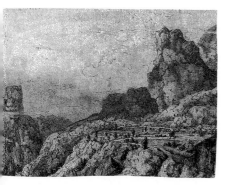

It was probably not long after the invention of the woodcut, the first print medium, that someone had the imaginative idea of hand coloring them. With the exception of some single leaf devotional woodcuts, most hand colored prints in the fifteenth century were book illustrations (fig. 1). These prints enlivened the page and created affordable versions of the one-of-a-kind illuminated manuscripts produced prior to Gutenberg. The coloring, however, was not added by the artist who designed the blocks, but by anonymous craftsmen whose sole aim was decoration. There was no sense or need of artistic integration between the print and the color that went on it. The results, though often bold and expressive, were also crude and arbitrary.

One hundred and fifty years later, Hercules Seghers worked over his prints with watercolor in order to create unified works of art. Seghers and Rembrandt van Rijn are considered the most creative and experimental printmakers of seventeenth century Holland. Limiting his subjects to landscapes, seascapes, and occasional still-lifes, Seghers conveyed his highly original vision through choice of paper, printing, cropping, and the careful hand coloring of his prints (fig. 2). The resulting works are atmospheric, moody, and eccentric. As Clifford Ackley has written, "The translucent overlays of color in which the color of the support plays a part are one of the factors that make many impressions of Seghers prints so difficult to reproduce and often cause them to be viewed more as unique paintings than as etchings in the conventional sense."[1] Until the mid-eighteenth century, Seghers stood as a near solitary example of a creative printmaker willing to use hand coloring as an aspect of his creativity.

At the end of the eighteenth century only a few artists, like William Blake, colored their prints with care and creative intent. Their achievements were totally overwhelmed by the popularization of broadly drawn etchings embellished with garish watercolor, such as this one by Thomas Rowlandson (fig. 3). This etching was one of the mass produced satiric and caricature prints that could be bought "one penny plain or two penny colored." Hyatt Mayor has described Rowlandson's process: "To publish his caricatures while they still would sell as news, Rowlandson etched in rapid open lines for one deep bite of the acid. He then watercolored the first proof as a model to send upstairs in the publishing house of Rudolph Ackermann in the Strand, where French refugees copied the colors on the whole edition of prints."[2] The hand coloring was done rapidly and haphazardly, producing something more like an assembly line item than a work of art.

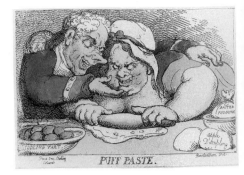

Fig. 3 Thomas Rowlandson (English, 1756–1827), *Puff Paste*, January 24, 1785 (reissued in 1812), etching with hand coloring, 147 x 222 mm, The Fine Arts Museums of San Francisco, Achenbach Foundation for Graphic Arts, 1963.30.2421

The other hand colored prints of the 1800s were scientific and topographic renderings. The floral etchings of Pierre Joseph Redouté and the engravings after John James Audubon's designs (fig. 4) were meticulously hand colored to reproduce the natural specimen's proper coloration. The prints were laboriously colored by studio craftsmen following a scientifically correct model.

The individual coloration of print proofs by the artist became more prevalent during the nineteenth century when the idea of the "peinture-graveur" developed. Numerous distinguished artists experimented with their prints, among them John Constable, Joseph Mallard, William Turner, Cornelius Varley, Adolphe Appian, Edouard Manet, Camille Pissarro, Mary Cassatt, Paul Cézanne, James Ensor, and Edouard Vuillard. However, three artists—Edgar Degas, Paul Gauguin, and Edvard Munch—raised experimental hand coloring of prints to a new level.

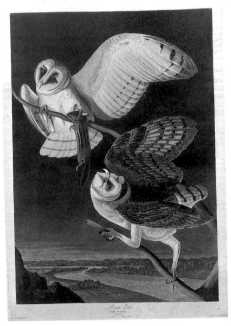

Fig. 4 Robert Havell (English, 1793–1878), after John James Audubon (American, 1785–1851), *Barn Owl*, 1833, pl. 171 from *The Birds of America*, aquatint engraving with hand coloring, 857 x 578 mm, The Fine Arts Museums of San Francisco, Achenbach Foundation for Graphic Arts

Printmaking, like painting, can be a very premeditated act. Just as a painting is worked and reworked until it is satisfactory, a print goes through various states before a final version is achieved and the edition pulled. Artists such as Degas, Gauguin, and Munch—and similarly Wayne Thiebaud—resist standardized printmaking, often preferring to reinvent and re-energize the print by applying other media, such as watercolor, pastel, and crayon, on individual proofs.

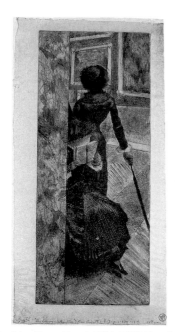

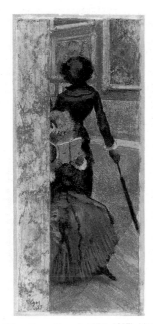

Edgar Degas was constantly experimenting and stretching the boundaries of print-making. His obsessiveness with the printmaking process led his friend the artist Marcellin Desboutin to write, "[Degas] is no longer a friend, he is no longer a man, he is no longer an artist! He is a 'plate' of zinc or copper blackened with printer's ink, and this plate and this man are rolled together by his press in the meshing of which he has disappeared completely! He is in the metallurgic phase for the repro-duction of his drawings with a roller and runs all over Paris in his zeal to find the equipment which corresponds to his fixed ideal!—It is altogether a poem!"[3]

In 1885, over five years after he had completed his important print *Mary Cassatt in the Painting Gallery of the Louvre* (figs. 5 and 6), Degas took a proof of the print and worked over the entire surface in pastel. The original print had been based on an earlier pastel drawing. In a sense, he brought the work full circle.

In the first half of the twentieth century, artists as diverse as Pablo Picasso, Georges Rouault, Max Weber, Paul Klee, Ernst Ludwig Kirchner (fig. 7), Emile Nolde, and Max Ernst experimented with hand coloring. In nearly all these experiments the artists colored working or artist's prints—as does Wayne Thiebaud—rather than the entire edition. Until the 1960s, however, the practice was frowned upon in formal printmaking circles. With the resurgence of creative printmaking in recent decades, an openness to experimentation has reemerged, encouraging artists to explore possibilities of hand coloring.

Today hand colored prints roughly fall into three categories. In the first, the artist colors a model which is used by studio assistants to color the entire edition. Artists Neil Welliver and Howard Hodgkin, among others, have made prints in this man-ner. In the second category the artist himself hand colors the complete edition of his print. Jim Dine, Lucian Freud, and Red Grooms have colored editions like this. In the case of Jim Dine's etching *Hearts and a Watercolor* (fig. 8), as with most of his hand colored editions, the artist doesn't attempt to make each print look the same. Instead, Dine colors them so as to create totally distinct and individual works. The third category is composed of work by artists using discarded trial or artist's proofs (often long after the formal edition has been pulled) as the beginning point of experi-mentation with the use of hand coloring. Like that of Degas, Gauguin, and Munch,

Wayne Thiebaud's work belongs in this category.

The working life of an artist is a journey without predetermined destination. It is a life of constant seeking, finding, and seeking again. Wayne Thiebaud uses the proofs of his prints to transform and revitalize those images through his masterly application of color. Whether by a few translucent washes or the near obliteration of an image under a heavy snowfall of powdery pastel, he makes us see with new eyes that which we thought we knew.

The work assembled in this volume is no mere group of fortunate experiments. Through this extended body of work, Wayne Thiebaud brings new sophistication, quality, and diversity to the hand colored contemporary print. His accomplishments link him to the distinguished practitioners of the past and set the standard for artists of the future.

Fig. 7 Ernst Ludwig Kirchner (German, 1880–1938), *Kühe im Mondschein (Cows in the Moonlight)*, 1919, etching with hand coloring, 252 x 280 mm, The Fine Arts Museums of San Francisco, Achenbach Foundation for Graphic Arts, purchase, 1966.80.42

1. Clifford S. Ackley, *Printmaking in the Age of Rembrandt,* Boston: Museum of Fine Arts, 1981, 56.

2. A. Hyatt Mayor, *Prints & People: A Social History of Printed Pictures,* New York: The Metropolitan Museum of Art, 1971.

3. Ian Dunlop, *Degas,* London: Thames and Hudson, Ltd., 1979, 163.

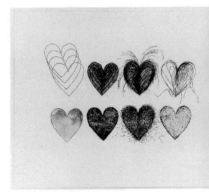

Fig. 8 Jim Dine (American, b. 1935), *Hearts and a Watercolor,* 1969, etching with watercolor, 346 x 546 mm, The Fine Arts Museums of San Francisco, Achenbach Foundation for Graphic Arts, NEA grant and Georgia M. Worthington Fund, 1978.1.146

Biography

1920 Born 15 November in Mesa, Arizona.

1936–37 Works briefly in animation department of Walt Disney Studios, Los Angeles.

1938 Attends Frank Wiggins Trade School, Los Angeles, to study commercial art.

1940–41 Attends Long Beach Junior College (now Long Beach City College).

1942–45 Serves in United States Army Air Force. In the last months of service is transferred to Air Force Motion Picture Unit, Culver City.

1946–49 Works as layout designer and cartoonist for Rexall Drug Company, Los Angeles.
Meets sculptor Robert Mallary.

1949–50 Attends San Jose State College (now San Jose State University).

1950–53 Attends California State College (now California State University), Sacramento. Receives B.A. in art (1951).
Produces serigraphs and lithographs with Patrick Dullanty.

1950–59 Serves as exhibit designer for annual art exhibition of the California State Fair and Exposition, Sacramento.

1951–60 Receives appointment as instructor of art, Sacramento Junior College (now Sacramento City College). Chairman of Art Department (1954–56, 1958–60).

1954 Produces an instructional film on lithography, *Color on a Stone,* with Patrick Dullanty at Bailey Films, Hollywood.

1956–57 Takes sabbatical from teaching to live in New York. Meets Elaine and Willem de Kooning, Franz Kline, Barnett Newman, Philip Pearlstein, Milton Resnick, and Harold Rosenberg, among others.

1958 Serves as guest instructor in printmaking, California School of Fine Arts (now San Francisco Art Institute), substituting for Nathan Oliveira.

1960 Appointed Assistant Professor, Department of Art, University of California, Davis. Subsequently appointed Associate Professor (1963–67) and Professor (1967 to present).

1961 Receives University of California Faculty Fellowship. Visits New York. Meets Allan Stone, Allan Stone Gallery, New York.

1962	Has one-person show in New York, "Wayne Thiebaud: Recent Paintings," Allan Stone Gallery.
	Has first one-person museum exhibition in San Francisco, "An Exhibition of Paintings by Wayne Thiebaud," M.H. de Young Memorial Museum.
	Included in the group exhibition "New Realists," Sydney Janis Gallery, New York.
1963	Begins long association with Kathan Brown of Crown Point Press, Oakland (currently located in San Francisco and New York).
1965	Portfolio of etchings, "Delights," published by Crown Point Press, Oakland.
1967	Meets Robert Feldman, Parasol Press, New York.
1968	Receives commission from *Sports Illustrated* to paint Wimbledon Tennis Tournament, England.
1970	Works on series of linocuts, Arnera Printshop, Vallauris, France.
1972	Appointed thirty-first Faculty Research Lecturer, University of California, Davis.
	Receives honorary doctorate, California College of Arts and Crafts, Oakland.
	Establishes second home in San Francisco.
1976	Begins weekly drawing sessions in San Francisco with group of Bay Area artists including Mark Adams, Theophilus Brown, Gordon Cook, and Beth Van Hoesen.
1981	Receives citation from College Art Association of America as Most Distinguished Studio Teacher of the Year (1980–81).
1983	Receives honorary doctorate, Dickinson College, Carlisle, Pennsylvania.
1984	Receives special citation award from National Association of Schools of Art and Design.
1985	Elected to American Academy and Institute of Arts and Letters, New York.
1986	Elected as Associate of National Academy of Design, New York.
1987	Advances from Associate of National Academy of Design, New York, to Academician.
	Receives Cyril Magnin Award for Outstanding Individual Achievement in the Arts on behalf of San Francisco Chamber of Commerce.
	Receives Award of Honor for distinguished service to the arts, San Francisco Arts Commission.
	Honoree, American Academy of Achievement.
1988	Receives University of California, Davis $25,000 Prize for Teaching and Scholarly Achievement.
	Receives Honorary Doctorate Award from San Francisco Art Institute.
	Elected as Fellow to the American Academy of Arts & Sciences, Boston.
	Begins series of lithographs with Trillium Graphics, Brisbane, California.
1990	Receives Distinguished Service Award, California State University, Sacramento.

Selected One-Person Exhibitions

1951 *Influences on a Young Painter*, E.B. Crocker Art Gallery (now Crocker Art Museum), Sacramento.
Wayne Thiebaud: Prints, California State Library, Sacramento.

1954 *Paintings: Wayne Thiebaud*, Gump's Gallery, San Francisco.

1957 *Thiebaud—Recent Works*, E.B. Crocker Art Gallery, Sacramento.

1958 *Recent Works of Wayne Thiebaud*, Artists Cooperative Gallery (now Artists Contemporary Gallery), Sacramento.

1960 *Wayne Thiebaud*, Art Gallery, Humboldt State College (now Humboldt State University), Arcata, California.
Paintings by Wayne Thiebaud, The Nut Tree, Vacaville, California.

1961 *An Exhibition of Recent Works by Thiebaud*, Art Unlimited, San Francisco.

1962 *Wayne Thiebaud: Recent Paintings*, Allan Stone Gallery, New York.
An Exhibition of Paintings by Wayne Thiebaud, M.H. de Young Memorial Museum, San Francisco.

1963 *Wayne Thiebaud: Recent Paintings*, Allan Stone Gallery, New York.
Wayne Thiebaud, Galleria Schwarz, Milan.

1964 *Thiebaud*, Allan Stone Gallery, New York.

1965 *Prints, Drawings, and Paintings by Wayne Thiebaud*, San Francisco Museum of Art (now San Francisco Museum of Modern Art).
Wayne Thiebaud, Allan Stone Gallery, New York.
Figures: Thiebaud, Stanford Art Museum (now Stanford University Museum and Art Gallery), California.
Delights, E.B. Crocker Art Gallery, Sacramento.

1967 *Wayne Thiebaud*, Allan Stone Gallery, New York.

1968 *Wayne Thiebaud*, Pasadena Art Museum (now Norton Simon Muscum), California.
Traveled to:
Walker Art Center, Minneapolis;
San Francisco Museum of Art;
The Contemporary Arts Center, Cincinnati;
Utah Museum of Fine Arts of the University of Utah.
Wayne Thiebaud, Allan Stone Gallery, New York.
Thiebaud, Milwaukee Art Center.

1969 *Recent Works by Wayne Thiebaud*, Allan Stone Gallery, New York.

1970 *Recent Works by Wayne Thiebaud*, E.B. Crocker Art Gallery, Sacramento.
Wayne Thiebaud: Recent Works, Allan Stone Gallery, New York.

1971 *Wayne Thiebaud Graphics: 1964–1971*, Whitney
Museum of American Art, New York, (organized
by Parasol Press, Ltd., New York).
Traveled to:
William Rockhill Nelson Gallery and Atkins
Museum of Fine Arts (now The Nelson-Atkins
Museum of Art), Kansas City;
Corcoran Gallery of Art, Washington, D.C. (1972);
Fort Wayne Museum of Art, Texas (1972);
Fort Worth Art Center Museum (now Fort Worth
Art Museum), Texas (1972);
Des Moines Art Center (1972);
Achenbach Foundation for Graphic Arts,
California Palace of the Legion of Honor,
San Francisco (1972);
Wadsworth Atheneum, Hartford (1972);
Baltimore Museum (1972);
Phoenix Art Museum (1973);
Wallraf-Ritchartz Museum, Cologne,
West Germany (1975);
Arnolfini Gallery, Bristol, England (1976);
Bard College, Annandale-on-Hudson,
New York (1979).
*Wayne Thiebaud: Paintings, Pastels, Drawings,
and Prints*, John Berggruen Gallery, San Francisco.

1972 *Wayne Thiebaud*, Allan Stone Gallery, New York.
Wayne Thiebaud: Survey of Paintings 1950–72,
The Art Museum and Galleries (now University
Art Museum), California State University,
Long Beach.

1973 *Wayne Thiebaud: Paintings, Pastels, and Prints*,
John Berggruen Gallery, San Francisco.
Wayne Thiebaud, Paintings and Drawings 1958–1973,
Portland Center for the Visual Arts, Oregon.
*Works on Paper and Other Edibles: An Exhibition
of the Works of Wayne Thiebaud*, Holland Union
Gallery, Dickinson College, Carlisle, Pennsylvania.

Wayne Thiebaud: Recent Work, Allan Stone
Gallery, New York.

1974 *Thiebaud in Dakota*, University Art Gallery,
University of North Dakota, Grand Forks.
Paintings and Graphics by Wayne Thiebaud,
Genevieve and Donald Gilmore Art Center,
Kalamazoo Institute of Arts, Michigan.
*Wayne Thiebaud: Paintings, Drawings, and
Prints*, Church Fine Arts Gallery (now Sheppard
Gallery), University of Nevada, Reno.

1975 *Wayne Thiebaud: Prints, Drawings, Paintings*,
Colorado State University, Fort Collins.
Traveled to:
The Denver Art Museum.
Wayne Thiebaud, Edwin A. Ulrich Museum
of Art, Wichita State University.

1976 *Wayne Thiebaud: Paintings and Works on Paper*,
Mary Porter Sesnon Art Gallery, University of
California, Santa Cruz.
Wayne Thiebaud, Allan Stone Gallery, New York.
Wayne Thiebaud: Survey 1947–1976, Phoenix
Art Museum.
Traveled to:
The Oakland Museum (1977);
University of Southern California Art Galleries,
Los Angeles (1977);
Des Moines Art Center (1977);
Neuberger Art Museum, State University of
New York, Purchase (1977);
Institute of Contemporary Art, Boston (1977).

1977 *Wayne Thiebaud/Strictly Personal*, Delphian
Gallery, Sheridan, Oregon.
Wayne Thiebaud: Drawings, Memorial Union Art
Gallery, University of California, Davis.
Wayne Thiebaud: Creations on Paper, Visual Arts

Gallery, College of Saint Catherine, Saint Paul, Minnesota.

1978 *Wayne Thiebaud: Recent Work*, San Francisco Museum of Modern Art.
Wayne Thiebaud: Works on Paper, Boise Gallery of Art, Idaho.

1979 *Wayne Thiebaud: San Francisco Paintings*, Allan Stone Gallery, New York.

1980 *Wayne Thiebaud: Paintings, Pastels, and Prints*, John Berggruen Gallery, San Francisco.
Wayne Thiebaud: Paintings and Drawings, Charles Campbell Gallery, San Francisco.
Wayne Thiebaud, Art Gallery, College of the Mainland, Texas City, Texas.
Thiebaud, Allan Stone Gallery, New York.
Wayne Thiebaud, Van Staveren Fine Art, Sacramento.
Wayne Thiebaud, Art Center College of Design, Pasadena.

1981 *Wayne Thiebaud: Painting*, Walker Art Center, Minneapolis.
Wayne Thiebaud, Laguna Beach School of Art, California.
Paintings and Prints by Wayne Thiebaud, Robert Mondavi Winery, Oakville, California.

1982 *Wayne Thiebaud*, Art Museum of Santa Cruz County, Santa Cruz, California.
Wayne Thiebaud: Prints, Gallery Hiro, Tokyo.
Traveled to:
Yoh Art Gallery, Osaka.
Wayne Thiebaud: Recent Paintings, Allan Stone Gallery, New York.
Thiebaud Graphics, Sheehan Gallery, Whitman College, Walla Walla, Washington.

Prints and Paintings by Wayne Thiebaud, Marsh Gallery, University of Richmond, Virginia.

1983 *Wayne Thiebaud: Landscapes & City Views*, Crocker Art Museum, Sacramento.
Wayne Thiebaud: Paintings, Drawings, Graphics 1961–1983, The Trout Gallery, Emil R. Weiss Center for the Arts, Dickinson College, Carlisle, Pennsylvania.

1985 *Wayne Thiebaud*, organized by the San Francisco Museum of Modern Art to celebrate its 50th anniversary.
Traveled to:
San Francisco Museum of Modern Art;
Newport Harbor Art Museum, California (1986);
Milwaukee Art Museum (1986);
Columbus Museum of Art, Ohio (1986);
The Nelson-Atkins Museum of Art, Kansas City, Missouri (1986).

1987 *Wayne Thiebaud: Works on Paper from the Collection of the Artist*, The Arts Club of Chicago.
Traveled to:
Georgia State University Art Gallery, Atlanta.

1988 *Wayne Thiebaud: Works on Paper, 1947–1987*, organized by the Richard L. Nelson Gallery, University of California, Davis.
Traveled to:
Stanford University Museum of Art;
Northern Arizona University Art Gallery, Flagstaff;
University Art Gallery, University of California, Riverside (1989);
Fresno Art Museum, Fresno, California (1989);
Museum of Art, University of Oklahoma (1989);
Fine Arts Gallery, University of California, Irvine (1989);

Institute for Contemporary Arts, University of
Nevada, Las Vegas (1990).
Wayne Thiebaud: Prints and Works on Paper,
Rutgers Barclay Gallery, Santa Fe.
Wayne Thiebaud, Allan Stone Gallery, New York.
Wayne Thiebaud: Prints and Other Rarities,
Charles Campbell Gallery, San Francisco.

1989 *Wayne Thiebaud: Works on Paper*, Mead Art
Museum, Amherst College, Amherst,
Massachusetts.

1990 *Wayne Thiebaud: Prints and Hand Colored
Etchings*, Karsten Schubert, Ltd., London.
Wayne Thiebaud: Sketchbook Selections,
Rutgers Barclay Gallery, Santa Fe.
*Thiebaud at Seventy: A Retrospective Selection of
Paintings, Drawings, Watercolors, and Prints,
Including New Work*, Hearst Art Gallery,
Saint Mary's College, Moraga, California.

Selected Bibliography

Figures: Thiebaud. Stanford: Stanford University Press, 1965.

John Coplans. *Wayne Thiebaud.* Pasadena: Pasadena Art Museum, 1968.

Wayne Thiebaud Graphics: 1964–1971. New York: Parasol Press, 1971.

Wayne Thiebaud: Survey of Paintings 1950–1972. Long Beach: California State University, Long Beach, 1972.

Wayne Thiebaud: Survey 1947–1976. Phoenix: Phoenix Art Museum, 1976.

Wayne Thiebaud: Paintings, Pastels, Drawings and Prints. San Francisco: John Berggruen Gallery, 1980.

Graham W. J. Beal. *Wayne Thiebaud: Painting.* Minneapolis: Walker Art Center, 1981.

Wayne Thiebaud. Santa Cruz, California: Art Museum of Santa Cruz County, 1982.

Wayne Thiebaud: Paintings, Drawings, Graphics 1961–1983. Carlisle, Pennsylvania: Dickinson College, 1983.

Karen Tsujimoto. *Wayne Thiebaud.* San Francisco and Seattle: San Francisco Museum of Modern Art and University of Washington Press, 1985.

Wayne Thiebaud: Private Drawings, The Artist's Sketchbook. New York: Abrams, 1987.

Thiebaud at Seventy. Moraga, California: Saint Mary's College, 1990.

Wayne Thiebaud: Prints and Hand Colored Etchings. London: Karsten Schubert, 1990.

8542

Designed by Ingalls + Associates
Composed in Futura and Sabon by On Line Typography
Printed and bound by Toppan Printing Co., Ltd.

This volume is also published in a limited edition of one
hundred copies in slipcases, each of which is signed and
numbered by Wayne Thiebaud.